IMAGES
of America

EDISON AND FORD
IN FLORIDA

*T*oday, **visitors to the Edison & Ford Winter Estates** enjoy
the original winter homes, gardens and laboratory of Thomas
Edison and Henry Ford much as they were in the 1920's. One
of the ten most visited historic home sites in the country, the site
is on the National Register of Historic Places and has won top
awards from the National Trust for Historic Preservation and
National Garden Clubs, Inc.

Photographs from the archives of the Edison Ford and research
sites throughout the nation illuminate the Florida legacies of these
two great innovators and their families. The authors are historians
who are employed by the Edison & Ford Winter Estates.

Chris Pendleton, President & CEO
Mike Cosden, Chief Operating Officer
Brent Newman, Chief Curator

www.edisonfordwinterestates.org

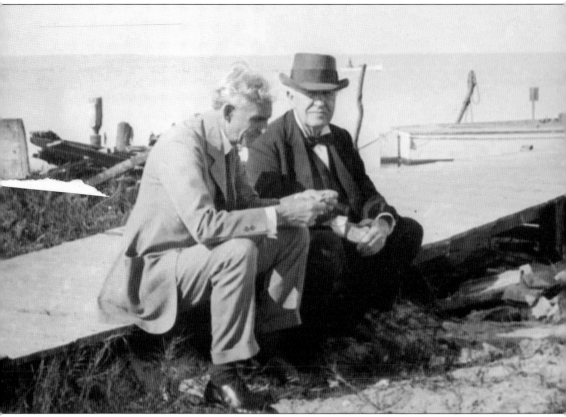

Henry Ford (left) and Thomas Edison relax at the base of the pier on Edison's Fort Myers estate, Seminole Lodge, around 1925. Their decades-long friendship would help shape the development of Florida, and today, their neighboring estates stand as a reminder of their legacy of innovation. (Courtesy of the Edison & Ford Winter Estates.)

ON THE COVER: Henry Ford and Thomas Edison pose in front of Edison's 1886 laboratory in Fort Myers in 1928. (Courtesy of the Edison & Ford Winter Estates.)

IMAGES
of America

EDISON AND FORD IN FLORIDA

Mike Cosden, Brent Newman, and Chris Pendleton
for the Thomas Edison & Henry Ford Winter Estates

ARCADIA
PUBLISHING

Published by Arcadia Publishing
Charleston, South Carolina

Printed in the United States of America

Library of Congress Control Number: 2015935035

For all general information, please contact Arcadia Publishing:
Telephone 843-853-2070
Fax 843-853-0044
E-mail sales@arcadiapublishing.com
For customer service and orders:
Toll-Free 1-888-313-2665

Visit us on the Internet at www.arcadiapublishing.com

*"There is only one Fort Myers in the United States, and there
are 90,000,000 people who are going to find it out."*
—Thomas Edison, 1914

*To the volunteers of the Edison & Ford Winter Estates,
whose contributions are invaluable and immeasurable.*

CONTENTS

ACKNOWLEDGMENTS

The authors wish to acknowledge the contributions of Edison & Ford Winter Estates staff members Andrew Schiep, whose countless hours spent locating and scanning images made this book possible, Pearce Augustenborg, and proofreaders Matthew Andres and Janet Wilson—thank you for your patience and attention to detail. Special thanks must be given to Alison Giesen; Dr. Ann Wilson; Mark Campbell, treasurer of the Henry Ford Heritage Association; Nancy Darga, executive director, and Sara Schultz, education and visitor services coordinator of the Ford Piquette Avenue Plant; the volunteers and staff of the Southwest Florida Historical Society; Jim Powers, research historian with the Southwest Florida Museum of History; the staff at the Benson Ford Research Center at the Henry Ford, including image services specialist Jim Orr; Butch Wilson, director of the Clewiston Museum; Neal "Adam" Watson with the Florida Memory Project; Leonard DeGraaf, archivist at Thomas Edison National Historical Park; Tom Smoot; and Madeline Plummer.

Unless otherwise noted, all images appear courtesy of the Edison & Ford Winter Estates.

INTRODUCTION

Life, as I see it, is not a location but a journey.

—Henry Ford, c. 1923

Few individuals have shaped our modern world more than Thomas Edison and Henry Ford. Combined, these two innovators held a total of 1,254 US patents, guiding the course of the 20th century. Both Edison and Ford were self-made men with humble beginnings—Ford was born on a farm outside of Detroit, Michigan; Edison, in the modest shipping town of Milan, Ohio. Neither man received an extensive formal education. Still, by the time they purchased winter estates on the banks of the Caloosahatchee River in Fort Myers, Florida, they had become two of the most celebrated men in the country.

Thomas Edison, known as the "Wizard of Menlo Park," astonished the world with the invention of the phonograph, the first device that could both record and play back sound. He continued to fascinate and inspire with his improved incandescent lightbulb and associated electrical system, which helped to usher in the dawn of the electrical age. But, Edison was also involved in a variety of other industries, from cement production to the early film industry.

Henry Ford was 16 years younger than Thomas Edison, the man who would become a mentor and close friend. Ford's automotive innovations in the early 20th century, and his revolutionary "$5 a day" wage for factory workers, made him a household name. By applying the assembly line to the industry, he was able to drastically reduce the cost to produce each automobile. Thanks in part to its low-cost assembly-line production, as well as its simple, rugged design, the Ford Model T became one of the best-selling vehicles of all time, making Henry Ford a billionaire in the process.

Together, Edison and Ford cultivated a decades-long friendship, which would in turn spark further creative innovation and collaborative projects. The two worked together to improve Ford automobiles and began a tradition of camping trips with friend Harvey Firestone, who would join Henry Ford and Thomas Edison for the wizard's final research project: a search for a natural source of rubber that could be grown in the United States.

To understand the historic friendship and lasting impact of these American icons, consider the time line of their lives, which frequently intersected in Florida, the state they both chose to call their winter home:

1847	Thomas Edison is born in Milan, Ohio
1863	Henry Ford is born in Dearborn, Michigan
1868	Edison applies for his first patent, the electric vote recorder
1871	Edison marries Mary Stillwell, with whom he will have three children
1878	Edison gains international renown for his invention of the phonograph and electric lighting experiments
1879	Edison demonstrates his improved incandescent lightbulb
	Ford leaves the farm and begins working in Detroit, Michigan
1884	Edison's wife, Mary Stillwell, dies at the age of 29
1885	Edison visits Ford Myers, Florida, for the first time and purchases 13.5 acres for a winter estate
1886	Edison marries Mina Miller, with whom he will have an additional three children, constructs a home and laboratory in Fort Myers, and purchases Glenmont, his year-round estate in New Jersey
1888	Edison begins work in the motion-picture industry
	Ford marries Clara Bryant
1891	Ford begins working for the Detroit Edison Illuminating Company
1893	Edison constructs the Black Maria film studio in West Orange, New Jersey
	Ford's first and only child, Edsel, is born
1896	Edison and Ford meet for the first time, at a conference for the Edison Illuminating Company, where they discuss Ford's gas-powered automobile, the Quadricycle
1903	Edison releases *The Great Train Robbery*, a landmark film
	The Ford Motor Company is incorporated
1908	Ford begins production of the Model T
1910	Edison completes major renovations of his Fort Myers estate
	Ford opens the Highland Park factory in Michigan
1914	Edison and Ford take the first in a series of noteworthy camping trips together, to the Florida Everglades
	Ford announces the historic "$5 a day" wage increase for factory workers
1916	Ford purchases the home adjacent to Edison's winter estate in Fort Myers
1927	Edison, Ford, and Harvey Firestone form the Edison Botanic Research Corporation and begin a search for a natural rubber plant that can be grown in the United States
1928	The Edison Botanic Research Corporation Laboratory is built in Fort Myers
	Ford finances a number of improvements to Edison's Fort Myers estate and moves Edison's original 1885 Fort Myers laboratory to Greenfield Village, in Michigan
1931	Edison passes away
1932	Ford begins production of his revolutionary new V-8 engine
1947	Mina Miller Edison deeds her estate to the City of Fort Myers and passes away later that year; the Edison estate opens to the public shortly thereafter
	Ford passes away
1966	A museum building is added to the Edison estate and dedicated by Charles Edison, son of Thomas and Mina
1988	The Ford estate is purchased by the City of Fort Myers
1990	The Ford estate is opened to the public
2003	A nonprofit corporation is formed to manage and preserve both estates
2009	The estates win the National Stewardship Award from the National Trust for Historic Preservation
2014	The fully restored Edison Botanic Research Corporation Laboratory is named a National Historic Chemical Landmark by the American Chemical Society. After more than a decade of award-winning work restoring the estates, the site carries the legacies of Thomas Edison and Henry Ford into the future

One

BUILDING A

FLORIDA RETREAT

The air here is perfect; the weather, as you see, is beautiful, and the days are a constant succession of blue skies and warm sunshine, and to all this I owe my rapidly returned health.

—Thomas Edison, 1887

In 1885, renowned inventor and entrepreneur Thomas Edison traveled south from his New Jersey home to recover from illness and escape the bitterly cold winter. Joined by friend and business partner Ezra Gilliland, Edison stumbled upon the sleepy cattle-ranching town of Fort Myers, Florida. There, the 38-year-old inventor found a refuge not only from the cold but also from the daily pressures of life for a celebrity. Florida was also an escape from the tragedy that had plagued him the previous year, when his wife, Mary Stilwell, passed away. He was left to care for their three small children—Marion, Thomas Jr., and William. In Fort Myers, Edison purchased an estate on the banks of the Caloosahatchee River. The river was named after the Calusa, Native Americans living in the area when Spanish explorers first arrived in the 1500s. Edison proceeded to build adjacent winter homes for himself and Gilliland, as well as a laboratory where he could continue to experiment year-round.

Already a world-famous inventor, the Wizard of Menlo Park instantly became the most prominent Fort Myers citizen. By the time he arrived in southwest Florida, Edison had already received over 500 patents. He had become world-renowned for the phonograph, the first device that could both record and play back sound, and solidified his reputation with the improved incandescent lightbulb and associated generators, meters, and electrical systems. When Edison first turned on the electric lights at his winter estate in 1887, the *Fort Myers Press* reported that all 349 of the town's residents lined his fence. While Edison clearly had much to offer the state of Florida, he soon found it had much to offer him as well.

By 1885, Thomas Edison was an American icon in the midst of a great deal of change. After the loss of his first wife, relatives helped raise their three children before they attended boarding school and began their own careers. Marion, the eldest child, accompanied her father on his 1885 trip to Florida.

Thomas Edison was born in the river town of Milan, Ohio, on February 11, 1847. The Edison family lived in a modest home, pictured here during a visit in 1923, until moving to Port Huron, Michigan, in 1854. There, Edison received a short period of formal schooling, after which his mother, Nancy Elliott Edison, a former schoolteacher, continued his education at home. Edison later commented, "My mother was the making of me."

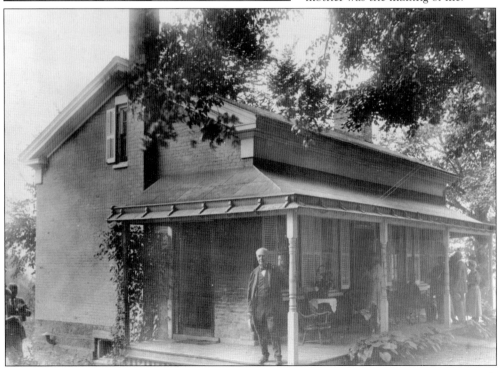

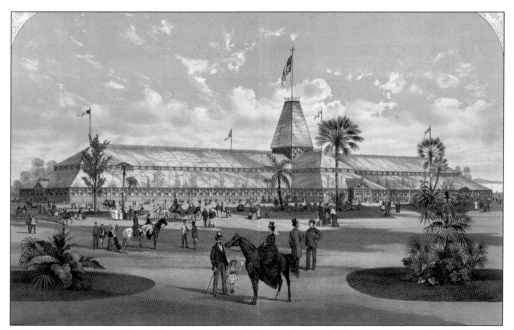

Always carefully considering his next project, Edison, along with business partner Ezra Gilliland, traveled to New Orleans in 1885, attending the World Industrial & Cotton Centennial. Surrounded by cutting-edge inventions, the pair discussed their own potential new innovations, including a "wireless telegraphy" concept, and found time to relax as well. It was here that Thomas Edison was first introduced to Mina Miller, his future bride. (Courtesy of the Popular Graphic Arts Collection, Library of Congress.)

From New Orleans, Edison and Gilliland ventured to Jacksonville and then on to Saint Augustine, Florida, a winter haven for the wealthy and famous. Seen here, the extravagant Ponce de Leon Hotel, built in 1885, was electrified by Edison's company. Eight tons of coal per day were required to produce the steam, which powered the hotel via 50,000 feet of electrical wiring. Parts of this system can still be viewed today. (Courtesy of the Detroit Publishing Company, Library of Congress.)

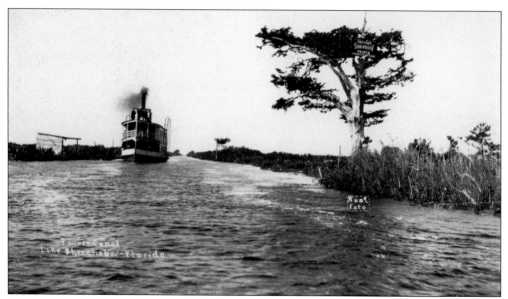

Because Saint Augustine was uncommonly cold that winter, Edison and Gilliland journeyed farther south. They first traveled west aboard the unreliable Florida Transitland & Peninsular Railroad, which ran off the track three times during their short trip, then ventured south aboard a chartered fishing boat. The pair finally arrived in the port town of Punta Rassa, Florida. Pictured here, a vessel navigates the waters of southwest Florida.

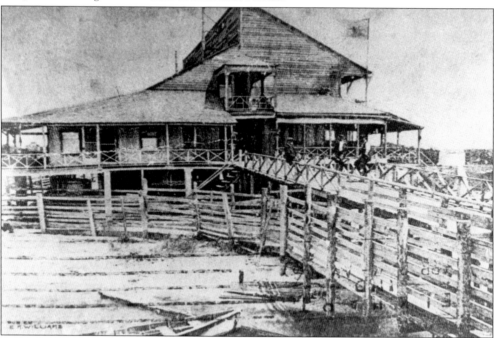

Located at the mouth of the Caloosahatchee River, Punta Rassa was a hub for cattle shipments to Cuba and Key West. Edison and Gilliland lodged at the Schultz Hotel, a former Civil War barrack. Before being loaded onto boats, cows were led through cattle chutes, seen here in front of the hotel. The hotel proprietor recommended that they visit the nearby "cow town" of Fort Myers, several miles upriver. (Courtesy of the Louise Frisbie Collection, Florida Memory.)

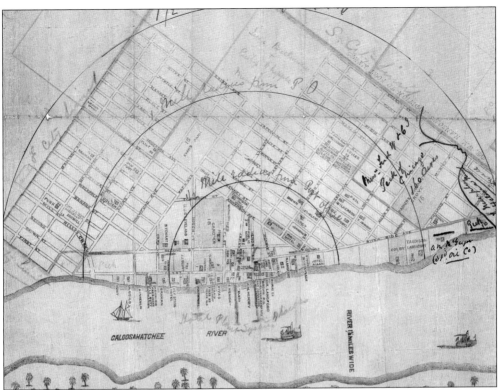

Like Punta Rassa, Fort Myers also had its roots in military history. First established during the Seminole Wars, then used by Union troops during the Civil War, Fort Myers was settled by civilians shortly after hostilities ended. At the time of Edison and Gilliland's visit, the community of less than 350 residents was not yet incorporated and populated primarily by cattle ranchers and their families.

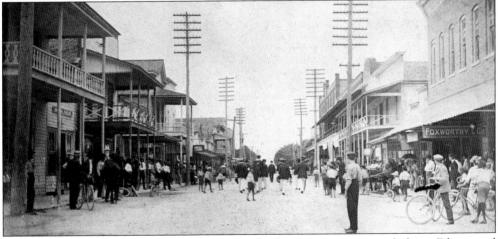

The dusty, unpaved streets of Fort Myers were far from the extravagant lodging Edison and Gilliland had experienced in Saint Augustine, yet the pair found the area enticing. This image, taken around 1900, shows the broad roadways, which cows still wandered at the time. Cattle remained a primary industry in the area until sportfishing and tourism overtook it in the 1890s and early 1900s. (Courtesy of Florida Memory.)

Fort Myers had many qualities Edison found attractive, including warm weather, a relaxing setting, and plentiful fishing. Perhaps most importantly, bamboo grew in Fort Myers, like the cluster seen growing here on the property he would eventually purchase. This plant was of particular interest to Edison; it was used as a filament in his improved incandescent lightbulb.

After spending just 24 hours in Fort Myers, Edison committed to purchasing 13.5 acres from local cattle baron Samuel Summerlin, paying $2,750. Shortly afterward, Edison drew this plan, laying out the location of homes for his and Gilliland's families and a laboratory. He also designed a landscape influenced by European gardens yet imbued with practicality and casual informality. (Courtesy of Thomas Edison National Historical Park.)

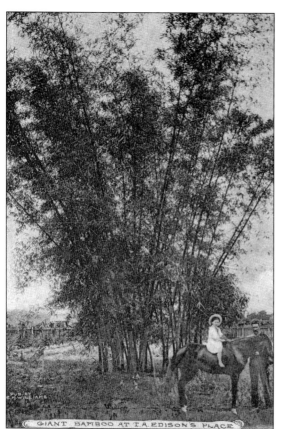

GIANT BAMBOO AT T.A. EDISON'S PLACE

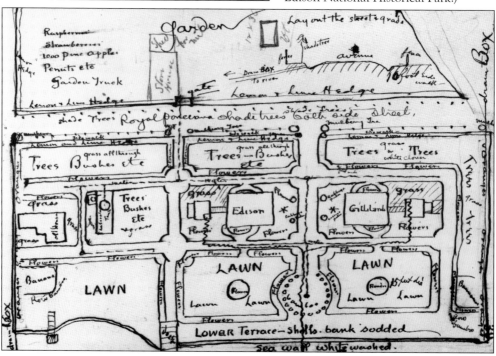

More changes were to come for Thomas Edison. Earlier in the year, he had been introduced to Mina Miller. Not long after meeting her, Edison revealed how smitten he had become, commenting, "Saw a lady who looked like Mina. Got thinking about Mina and came near being run over by a street car. If Mina interferes much more will have to take out an accident policy."

Mina Miller was born July 6, 1865, in Akron, Ohio. Daughter of agricultural inventor and cofounder of the Chautauqua Institute Lewis Miller, Mina was refined and worldly. She attended a ladies finishing school outside of Boston before traveling across Europe. According to his account, Thomas Edison taught Mina Morse code and proposed marriage by tapping out the message on her palm. They were soon married.

15

Before the Edisons could enjoy Fort Myers, logistical difficulties had to be overcome. The small town did not have a lumber mill, so the lumber for any new structures on the property had to be pre-milled in Maine before being shipped south. A dock was the first structure Edison erected on the estate to receive those shipments. It eventually extended a third of a mile into the wide, shallow Caloosahatchee River.

Just as he sketched the landscape design for his Fort Myers estate, Edison drew up plans for the homes themselves, sending them to Boston architect Alden Frink to create blueprints. The set of Victorian Queen Anne homes built for Edison and Gilliland were almost mirror images of one another.

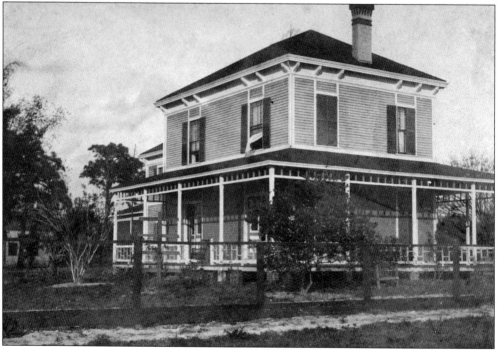

Each home featured two wings, which allowed the kitchen to be separated from the rest of the home, reducing the risk of fire damage. As seen here, initially, the homes featured modest porches, relatively small rooms, and single doors, but later renovations updated the architectural style. These Craftsman-style improvements included doubling the porch width, removing interior walls, and adding French doors.

Thomas Edison spent $12,000 to build and furnish his home but $16,000 on his laboratory. The original Fort Myers laboratory, seen here around 1925, allowed him to experiment while, presumably, on vacation. The secluded, subtropical setting of Fort Myers led Edison to explore new areas of research and further stimulated his interest in botany and horticulture.

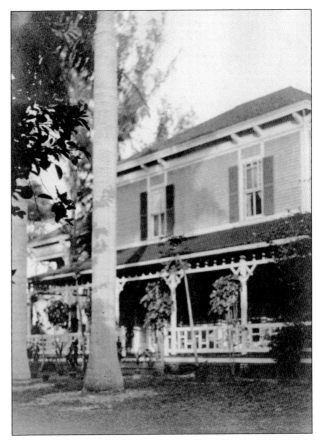

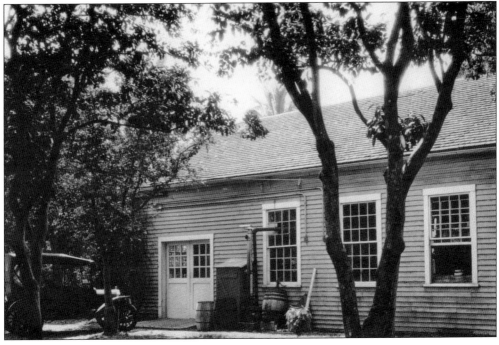

When Edison purchased his Fort Myers estate, a single structure referred to as "the old house" stood on the grounds. This structure is now believed to be one of the oldest still-standing buildings in the city of Fort Myers. Edison utilized the structure as lodging for his year-round caretakers and seasonal staff, including a chauffeur, whose children are seen here in front of the structure around 1930.

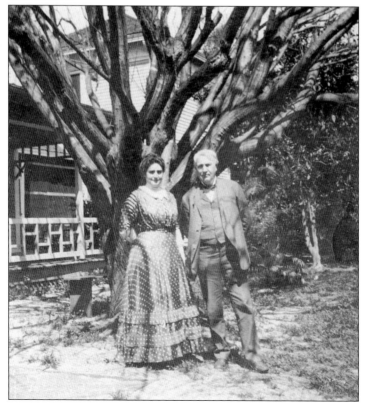

In 1886, Thomas and Mina honeymooned in Florida, a trip that included stops in Saint Augustine, Palatka, Tampa, and Fort Myers. The people of Fort Myers, wishing to greet the newlyweds, were urged not to host a public reception, opting instead for a private concert performed by the town's newly formed amateur band—which had been banned from playing within city limits just months earlier.

Thomas Edison also wanted to find a year-round home in New Jersey for his new wife. When asked if she would prefer to live in New York City or in the country, Mina selected the country, knowing that her husband would also favor the quiet. Pictured here, Thomas Edison relaxes in front of Glenmont, the Queen Anne mansion purchased in 1886 for $125,000.

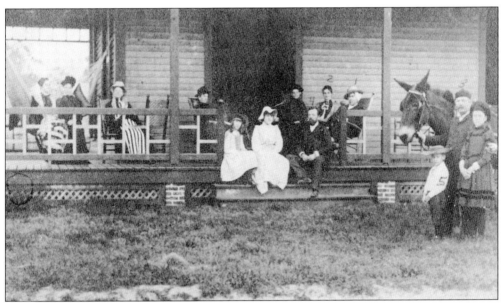

In this photograph, the Edison and Gilliland families relax on the Gillilands' porch around 1887. Edison and Gilliland were longtime friends and business partners who looked forward to wintering in Fort Myers together. However, only a few short years after they first visited Fort Myers, a business dispute drove a wedge between the two men, and they never spoke again. The Gilliland family sold their home in 1892. The Edison family did not visit Fort Myers again until 1901.

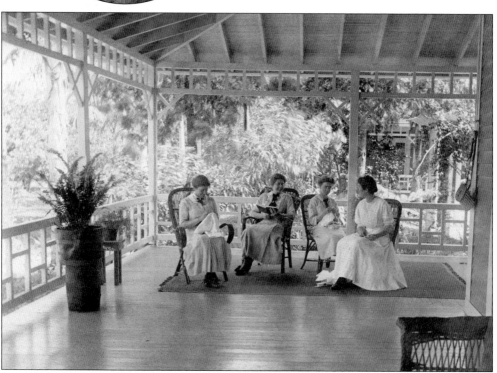

Mina Edison poses for a portrait surrounded by her three children—from left to right, Charles, Theodore, and Madeleine, around 1904. Another reason for the family's decade-long absence from Fort Myers was the birth of the three children in New Jersey. In fact, Thomas had so little faith in the doctor in Fort Myers that he sent him six medical textbooks.

In 1901, the Edison family once again began wintering in Fort Myers regularly. The residence of Edison's former colleague Ezra Gilliland came up for sale and was purchased by Edison in 1906. Today, it is known as the Guest House. The purchase prompted a series of renovations that took place from 1906 to 1910, including widening the porches. Madeleine Edison (far right) and three other women are seen here around 1910, reading and sewing on the newly widened porches.

Thomas and Mina Edison pose with their son Theodore around 1909 in front of the Edison home, which became known as the Main House. Theodore was named after his uncle Theodore Miller, who was mortally wounded in the Spanish-American War. Theodore Edison went on to receive a degree from Massachusetts Institute of Technology and became an inventor, like his father, earning more than 80 patents.

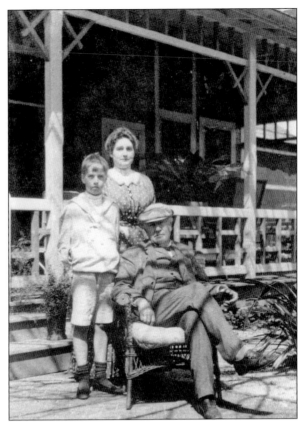

From an early age, Thomas Edison was a voracious reader. He had over 10,000 books in the library of his West Orange home and almost 1,000 books in Fort Myers. Today, Edison's original Fort Myers book collection is preserved in the estate's archive, while his library in the Main House is stocked with antique copies of the same titles he owned. Here, Edison reads a newspaper on the porch of Seminole Lodge around 1930.

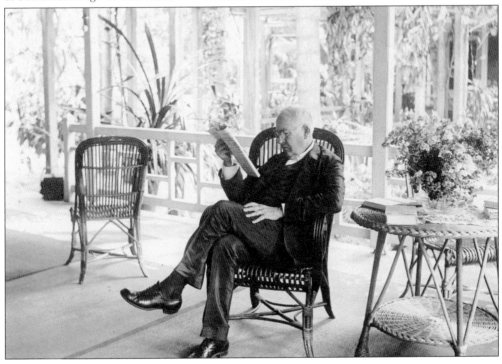

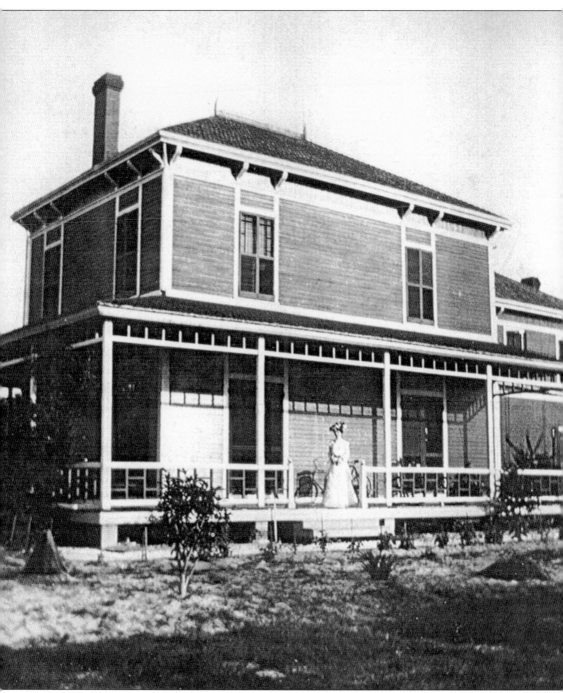

When the Edison family first began wintering in Fort Myers, they had to clear much of the 13.5-acre site to make room for the new homes, leading Mina to note, "There were no trees, not even a blade of grass—just piles of sand." Seen here around 1887, the grounds surrounding Seminole Lodge were relatively desolate for a time, especially since the Edisons did not visit their home for over a decade. By the turn of the 20th century, however, the Edisons resumed work on the grounds, transforming the landscape once more, creating a lush, densely vegetated estate.

Two

EDISON'S JUNGLE

I want to carry everything to extreme down there.

—Thomas Edison, 1886, referring to his Fort Myers gardens

After acquiring his Fort Myers property, industrious inventor Thomas Edison began to envision his winter paradise. While most frequently associated with his work on electricity, Edison's interests were wide and varied, including everything from chemistry to botany. Utilizing his extensive knowledge of the natural world, Edison personally designed his Florida landscape, incorporating practical fruits and vegetables, decorative plants, rare international trees, and native vegetation. From the start, his landscape also included flora and trees used in his experiments, such as bamboo and rubber-producing plants.

Mina Edison made her mark on the landscape as well, introducing plants to beautify and diversify the grounds. Mina's horticultural contributions included a diverse collection of orchids, which were showcased in an air garden. She also helped to create several formal garden spaces. The landscape was influenced by the additions of friends and neighbors Henry and Clara Ford. The Ford family purchased the next-door estate to spend more time with the Edison family and added their influence to the grounds.

The Edisons' botanical interests extended beyond their 13.5-acre estate to all of Fort Myers, as they engaged in varied projects to beautify the city and even helped earn it the moniker City of Palms.

After honeymooning at their estate in 1886, Thomas and Mina Edison frequently returned to Fort Myers to winter. Here, they not only fell in love with the beautiful environment, but also with the close-knit community, and locals began to see Thomas Edison as their favorite winter resident. The Edison property became known by a name selected by Mina, Seminole Lodge, a reference to the local Seminole tribe of Florida. Thomas Edison had his own name for the estate, simply and proudly referring to it as his "jungle."

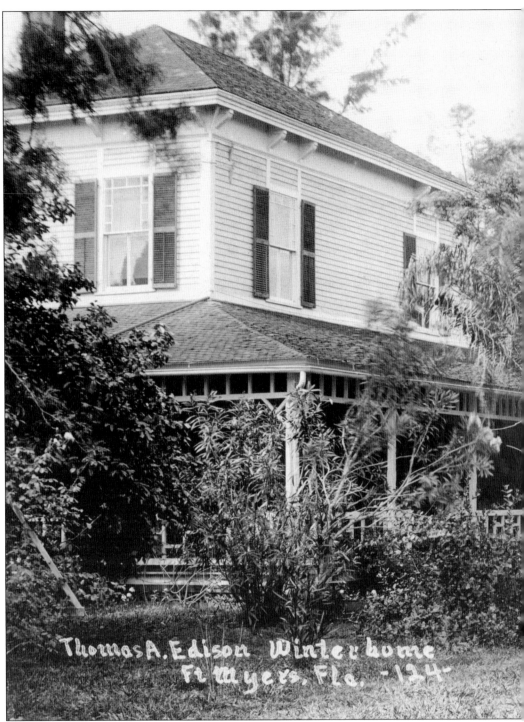

Thomas A. Edison Winter home
Ft Myers, Fla. -124-

Thomas Edison relaxes under a tree next to Seminole Lodge around 1920. Edison's interest in botany dated back at least as far as his experiments utilizing bamboo as a filament in the improved incandescent lightbulb. Even prior to this, Edison insisted on collecting a massive variety of items from the natural world for use in experiments in his laboratory. According to an 1887

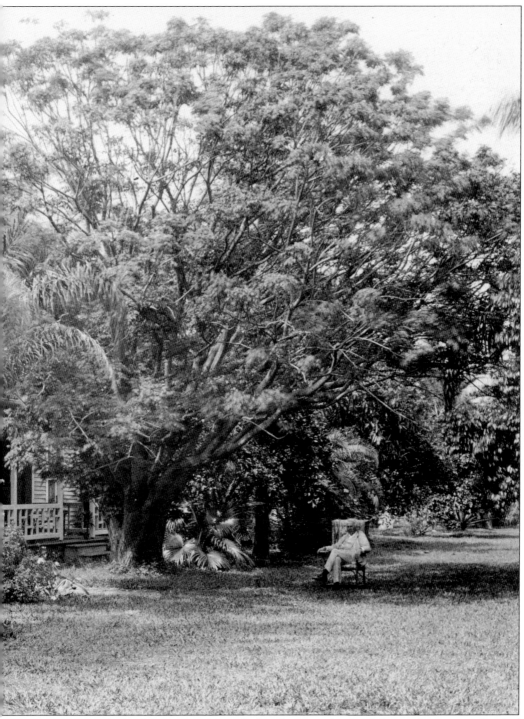

newspaper article, his laboratory was stocked with "8,000 kinds of chemicals . . . every kind of screw made . . . various kinds of hoofs, shark's teeth, deer horns, tortoise shell" and "a peacock's tail." In 1906, Edison commented, "I have always found [nature] ready for any emergency, and based on this confidence that she has never betrayed, I communed diligently with her."

After suffering from congestion and various illnesses, Edison was urged by his doctor to winter in a warmer climate. Even before the world-famous inventor first came to Florida, many wealthy and ailing Americans visited the state. Called the "Italy of America" by some and the "grand national sanitarium" by others, Florida was a popular winter vacation destination then as now.

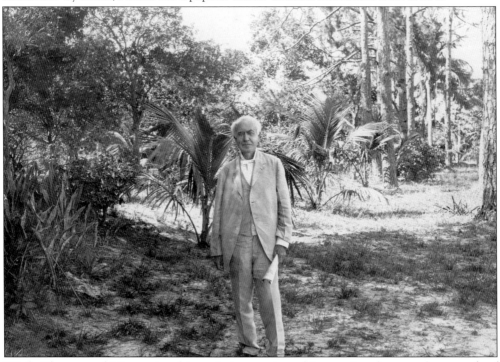

While Thomas and Mina enjoyed introducing exotic and interesting plants to the grounds of Seminole Lodge, they also admired the native vegetation of Florida. Here, Edison poses in front of a landscape comprised of a variety of Florida foliage, including slash pines, sabal palms, and saw palmetto. Because of Florida's naturally sandy soil, Edison asked that 2,240,000 wagonloads of "muck," or rich soil, be used to fertilize his property.

One of the many plants growing in Fort Myers that Edison found interesting was bamboo. In 1884, Edison patented a method to "produce flexible filaments . . . whose shape shall conform approximately to that of the glass globes which I use with my lamps. Such process consists in first cutting from a fibrous vegetable substance, preferably bamboo . . . then carbonizing said filament."

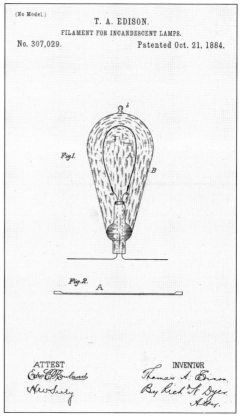

(No Model.)

T. A. EDISON.
FILAMENT FOR INCANDESCENT LAMPS.
No. 307,029. Patented Oct. 21, 1884.

ATTEST INVENTOR

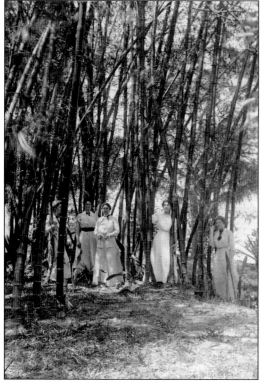

Madeleine (left) and Mina Edison (second from left), along with family friends, gather amongst a stand of bamboo on the grounds of Seminole Lodge around 1910. There are over 1,000 different species of bamboo, which is a type of grass. Some varieties can even grow up to 12 inches a day during the rainy season.

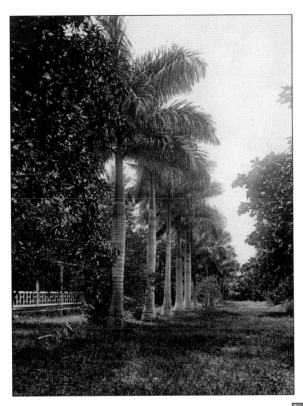

Edison designed the layout for the grounds of his winter home in an organized fashion, creating focal points, such as the fountain, and linear paths called allées. He also experimented with different types of grass seed for his lawn. Pictured here, a line of majestic royal palms forms one of the allées between Seminole Lodge and McGregor Boulevard, the road that divides Edison's property.

Along with planning the overall design, Thomas Edison also chose the specific plants that would inhabit the estates, filling one notebook with 25 pages of notes for his gardeners. The selections included orange trees, pineapple plants, poinciana trees, and native flowers. This view shows one of the allées leading to the fountain around 1915. Notice how much the gardens had evolved since the early days of the property in 1885.

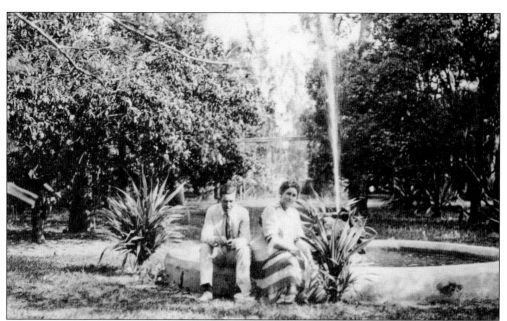

The fountain was one of the primary landscape features of Seminole Lodge. Centrally located, it provided the Edisons with a perfect vantage point to greet guests. Whether they arrived by boat or car, an allée led visitors straight to the fountain. In this photograph, Charles and Mina Edison relax by the fountain around 1909.

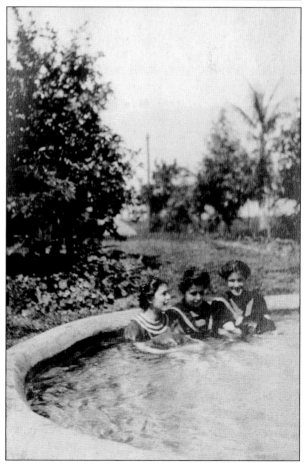

Before the Edisons finished construction of their swimming pool in 1910, the family and their guests were willing to do almost anything to stay cool on hot Florida days. Madeleine Edison (left) and two of her friends soak in the fountain, with a view of the Caloosahatchee River behind them, around 1909.

This photograph shows the Edison pier and dock house, which was added in 1902. The Edisons loved living on the banks of the Caloosahatchee River, but it was not without its drawbacks. In addition to powerful storms and the accompanying storm surge, another problem was water hyacinths. This invasive plant species grew along the shoreline, trapping sewage and waste and prompting Edison to have a wire fence installed along the river in the early 1890s.

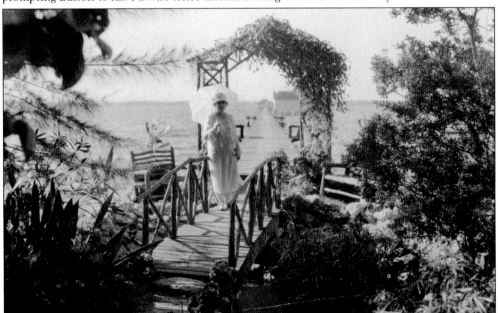

Mina Edison poses in front of the bougainvillea-draped arbor at the base of the pier around 1930. While Thomas created the initial garden plan, Mina would be influential in the evolution of the layout and makeup of the gardens. Mina was a proud wife to the famous inventor and took pleasure in managing the daily household activities. Eschewing the term *housewife*, Mina referred to herself as a "home executive."

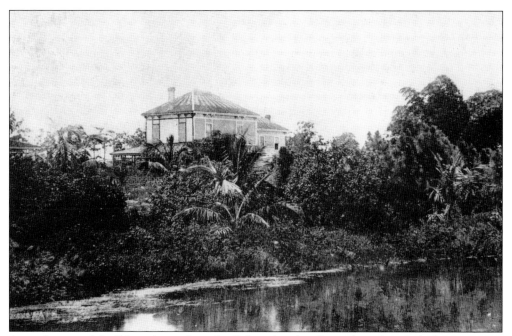

An early view of the Edison home from the Caloosahatchee River shows how lush the vegetation of the gardens of Seminole Lodge was. Coconut palms and red mangroves lined the waterfront, leaving no doubt as to why Edison referred to his winter estate as his jungle.

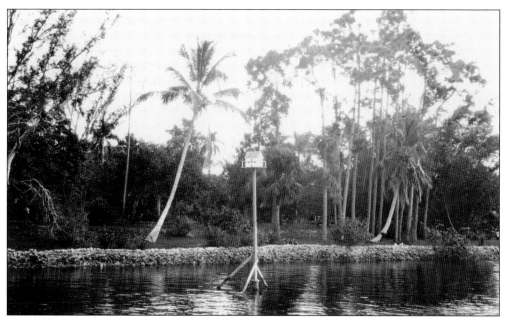

Several birdhouses, installed about 1920, were constructed to attract purple martins returning from their winter migrations to South America. Purple martins have long been thought to control mosquito populations, and building homes for them is still popular today. Note the unique location of this birdhouse, which offers protection from predators and an open area for nesting.

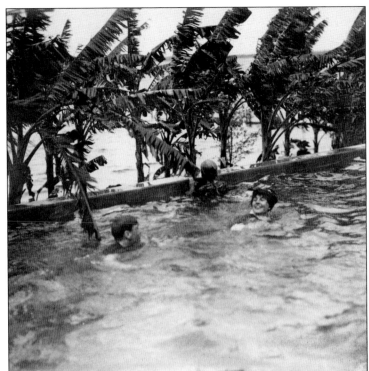

Madeleine Edison (right) and friends swim in the pool constructed in 1910. Note the row of banana trees planted behind the pool. The thick wind-torn leaves of these plants gave the family privacy from intrusive and inquisitive boaters on the Caloosahatchee River. While bananas are a fruit, the stalk on which they grow is actually an herb.

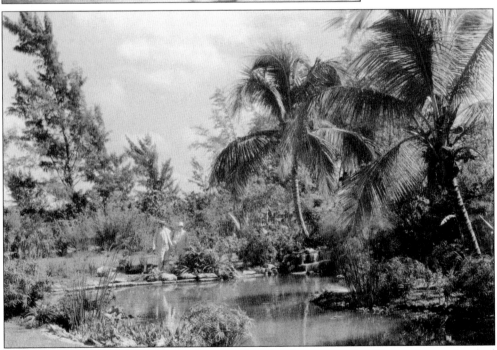

Like many of the unique landscape features that dot the estates, the lily pond served a dual purpose. First, it helped enhance the beauty of the pool complex. Second, it provided a way to drain excess water from the property and the pool into the river beyond. This sunny spot was a favorite of Thomas and Mina Edison, seen here around 1925.

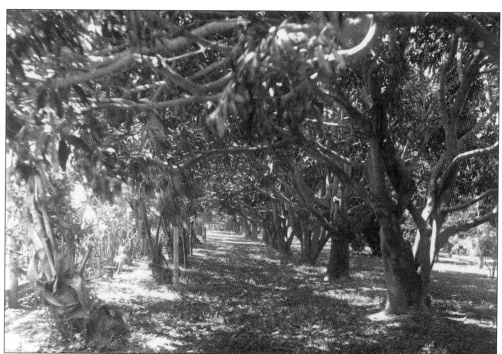

Mina Edison's love of flowers manifested itself in many parts of the estates. In 1908, the first documented orchid was brought to the property, and Mina wasted no time in adding more of the beautiful epiphytes. This photograph depicts the area called Orchid Lane, where orchids were tied directly onto trees. Today, there are more than 400 beautiful and rare orchids still thriving in the gardens of Seminole Lodge.

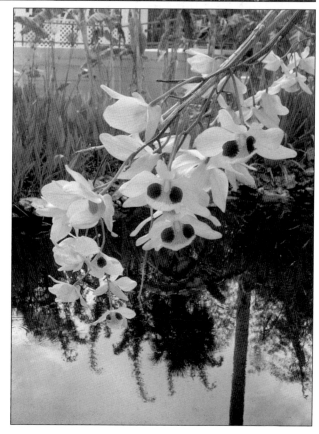

Like the orchid seen here, most cultivated orchids are epiphytes, or air plants, meaning that their root structure does not extend into the ground but instead attaches to a tree or rock, causing no harm to its host. Noting this during his visit to the estate in 1929, renowned botanist Henry Nehrling praised the air gardens created by the Edisons.

Seen here around 1905, the road that ran through Edison's Fort Myers property was initially known as the Old Wire Road, then Riverside Drive, and finally McGregor Boulevard. In an attempt to beautify it, Thomas Edison lined the road with royal palm trees imported from Cuba. Unfortunately, the shipment of palms was stopped at the local port due to a yellow fever quarantine. Edison's employee in charge of acquiring the palms commented, "The health authorities had done away with the Musquiter theaery as to transmision [sic] of yellow fever, and now think the only chance to transmit it is by Royal Palms." It would take Edison, seen at left next to a palm tree on the Seminole Lodge property around 1925, over a year to complete the job. Today, more than 10 miles of royal palms line McGregor Boulevard, earning Fort Myers the nickname City of Palms.

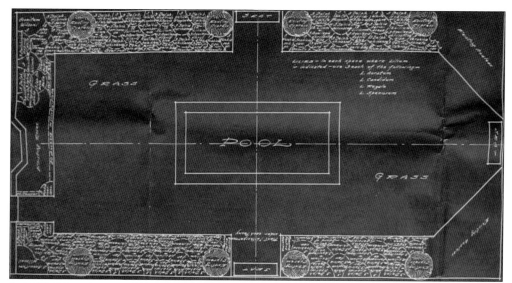

In 1928, Edison's original Fort Myers Laboratory was moved to Henry Ford's museum, Greenfield Village, in Dearborn, Michigan. In exchange, Ford financed a small study and the Moonlight Garden, filling the original footprint of the laboratory. The study was located close to Edison's home for the convenience of the elderly inventor. The Moonlight Garden, shown above, was designed by Ellen Biddle Shipman, one of the first female landscape architects in the United States. She was recommended by Henry and Clara Ford after designing a portion of the garden at their Michigan home. Intended to be enjoyed at night, the Moonlight Garden features a reflecting pond with tropical water lilies and many bright blue and white flowers. Seen below, Mina (left) and Carolyn, wife of Charles Edison, stroll through the garden around 1931; the study is seen in the background.

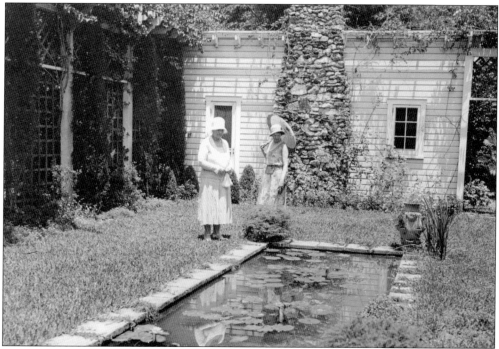

Thomas and Mina Edison enjoyed numerous hours working and relaxing in their tropical gardens. Pictured here in 1912, the couple meanders through their Fort Myers estate. Their interest in the natural world left a lasting impact on the grounds of their beloved Seminole Lodge, but their experimentation and innovation would not be restricted to their own estate—it would spill over into other projects throughout the state of Florida. Mina became involved in a variety of community projects, including efforts to beautify Fort Myers, and Thomas found a number of ways to continue his research year-round at his winter estate, including a rubber research project of international significance.

Three

INNOVATION AND
RELAXATION IN FLORIDA

It feels like living again to be back home in Fort Myers.

—Thomas Edison, 1931

Initially, Thomas Edison visited Florida to escape cold winters and the hustle and bustle of life in New Jersey. In Fort Myers, the pleasant weather and ample opportunities to enjoy the outdoors improved his health and disposition. But, with Edison's innovative mind, his winter residence quickly became a space for experimentation. Fort Myers would prove ideal for certain types of research due to its subtropical climate and its isolated location. Indeed, Edison spent more to build and outfit his Fort Myers laboratory than he did for his entire home. Research at Edison's laboratory in West Orange, New Jersey, did not have to pause while he was in Fort Myers. Here, he could continue experiments and stay in constant contact with his employees back north or even bring them to work for the winter in Fort Myers.

While in Florida, Edison found time to conduct other research across the state, including traveling to Key West to serve on the Naval Consulting Board during World War I. Edison also found creative ways to apply his innovations in Fort Myers, including creating several concrete structures out of his own brand of cement.

It was not all work and no play, however—the Edison family took full advantage of all Fort Myers had to offer, enjoying fishing, boating, and shelling in the surrounding waterways and islands. The Edison family frequently took excursions along the Caloosahatchee River aboard their electric boat, the *Reliance.* They explored nearby barrier islands like Sanibel and Captiva and journeyed upriver to Clewiston and Lake Okeechobee.

The Edison family also became involved with various community organizations, leaving their mark on many area charities. Along the way, they welcomed many famous guests, began to feel more at home in Fort Myers, and became ever more connected to the community and its residents.

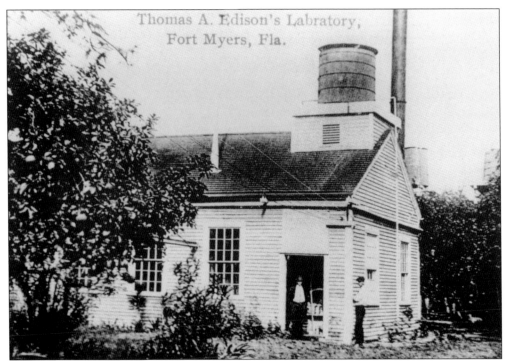

While Fort Myers was an escape from the cold winters and pressures of life as the Wizard of Menlo Park, it was also a place of continued experimentation. Shown here around 1900, Edison's original Fort Myers laboratory was equipped to continue research underway in his West Orange, New Jersey, facility. It housed a steam boiler, which provided electricity to Seminole Lodge beginning in 1887, over 10 years before the rest of the city was electrified.

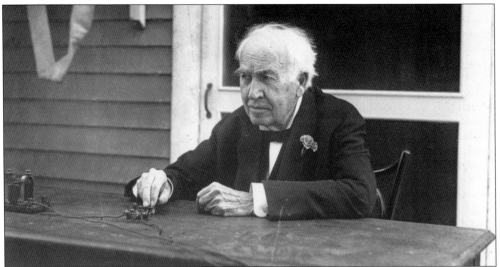

Edison did not restrict his Fort Myers experiments to the laboratory. He is seen here around 1930 operating a telegraph on the grounds of Seminole Lodge. In 1904, Edison told a reporter he was "working upon sound, trying to extend the distance at which telegraphing by sound through water can be successfully accomplished . . . I find the Florida waters best fitted for my experiments on account of their freedom from other sounds."

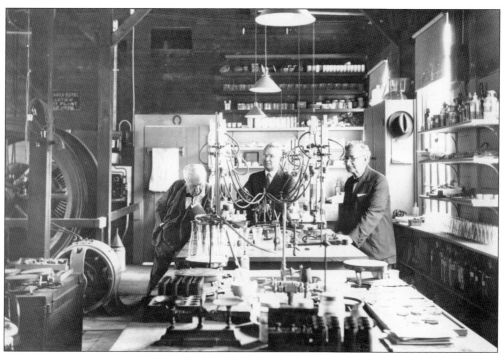

Note the similarities between Edison's original Fort Myers laboratory, above, around 1920, and his West Orange, New Jersey laboratory, at right, about 1910. The floor plan of Edison's laboratories remained relatively constant, including a machine shop, a row of worktables, a well-stocked supply of materials, and a separate office area, though the overall scale of his facilities varied. Machinist Fred Ott, pictured above, worked closely with Thomas Edison for decades, traveling back and forth with him from New Jersey to Florida and working in both laboratories. Ott was also the star of one of Edison's earliest films, *Edison Kinetoscopic Record of a Sneeze* (1894).

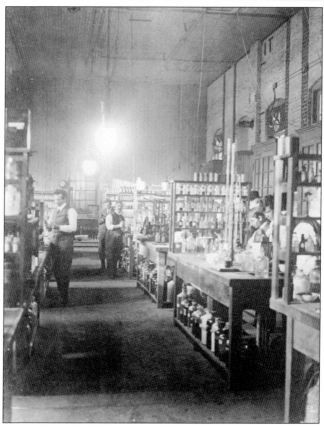

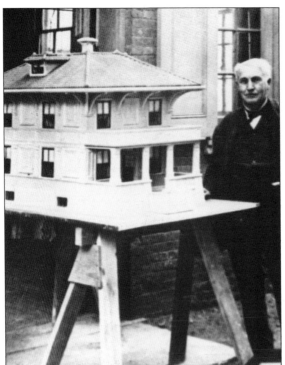

In addition to performing new research in Fort Myers, Thomas Edison also introduced some of his earlier innovations to his winter estate. His own brand of Edison Portland cement was used to construct several single-pour structures on the property, including the swimming pool, cistern, and chemical vault. At one point, the Edison Portland Cement Company was one of the largest producers of cement in the United States, and its product was used to build the Panama Canal and the original Yankee Stadium in New York City. Edison also marketed and built concrete homes. While these single-pour structures were not commercially successful, the residences were ahead of their time. At left, Edison poses with a model of a concrete home, and below, an Edison concrete home under construction in New Jersey—both around 1910.

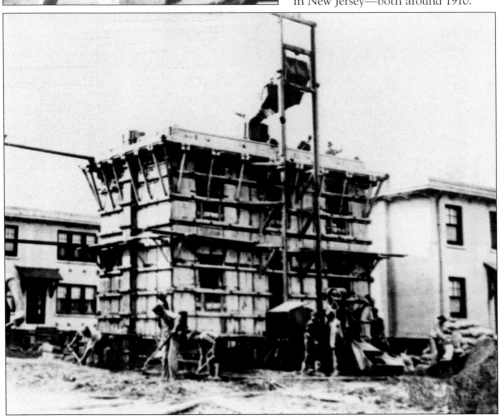

Edison's swimming pool was also constructed out of his Portland cement in 1910. It was likely the first private pool in southwest Florida. Caretaker James Anderson and two unidentified women enjoy the pool soon after it was completed. Thomas Edison, who believed in rigorously exercising the mind, was less concerned with physical activity. There is no record of him taking a dip in the swimming pool.

Accompanying the pool was a small dressing room. In 1928, a tea house, expanded area for changing rooms, and a shower were added. Featuring Italian tile, the tea house offered a shady space for family and friends to relax poolside. Here, Mina (left) and Carolyn Edison, wife of Charles Edison, enjoy the tea house in 1931.

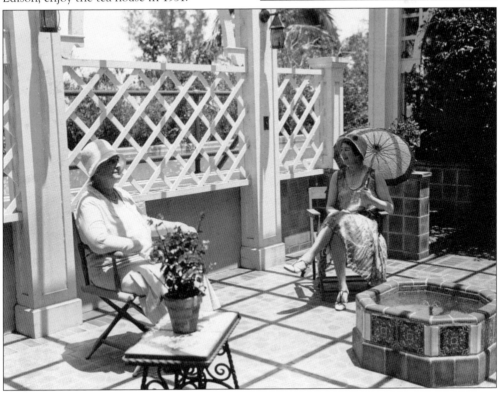

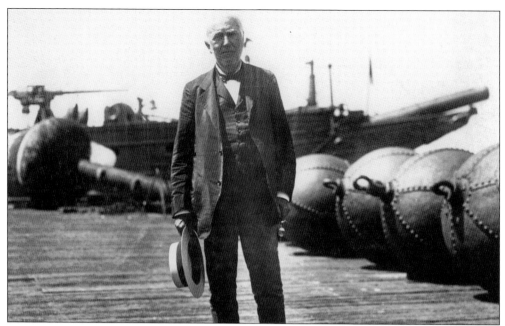

Thomas Edison's Florida research was not restricted to Fort Myers. Actively involved with the Naval Consulting Board during World War I, Edison became an expert on wartime preparedness. While in Florida, the inventor travelled to Key West to work on a variety of projects. His work focused on protecting American vessels from the threat of German submarines, including a rudder to rapidly turn ships, smoke screens to hide them, and methods of detecting vessels. Above, Edison poses in a Key West naval yard around 1915. Below is the Naval Consulting Board in 1916, including Edison, in Washington, DC. Assistant Secretary of the Navy Franklin Delano Roosevelt stands in the first row on the far right. (Above, courtesy of Florida Memory; below, courtesy of the Harris & Ewing Collection, Library of Congress.)

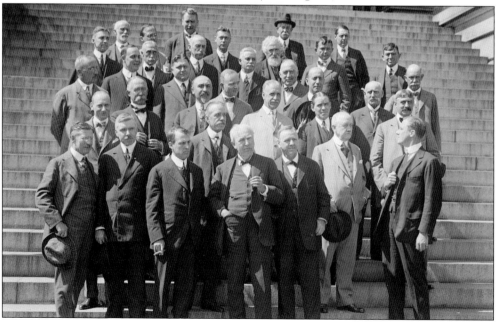

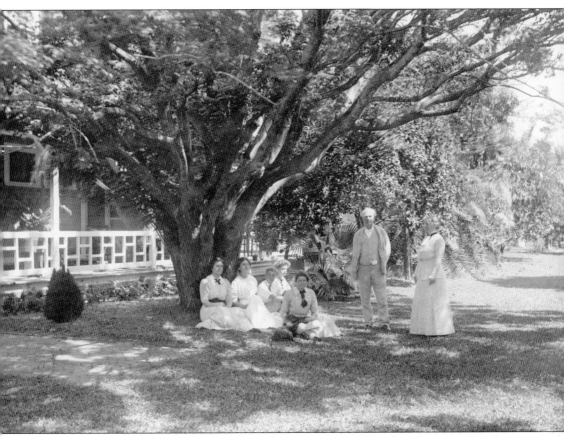

While in Fort Myers, the Edison family also found time to relax and explore the wilds of southwest Florida and attend social events around town. In what became a celebrated annual tradition, the town hosted many events for Thomas Edison's birthday. These festivities continue today and culminate in the Festival of Light parade, one of the largest nighttime parades in the United States. The Edisons enjoyed being able to relax in the many outdoor spaces afforded by Seminole Lodge, while family and friends up north were trapped indoor by winter weather. Here, Thomas, Mina, and Madeleine Edison (fourth from left) pose under a chinaberry tree next to the Main House with several guests around 1910.

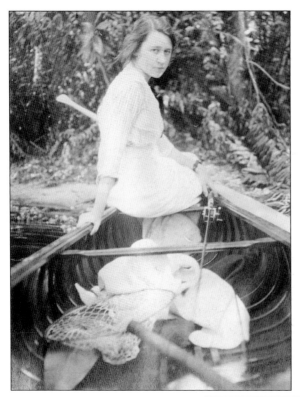

Madeleine Edison, eldest child of Thomas and Mina, possessed a wry sense of humor. Seen here boating in the waters of southwest Florida around 1906, Madeleine penned a series of amusing rules for guests of Seminole Lodge, which included "Don't cabbage unto yourself all the fish poles" and "Don't fail to retire to your room during part of each day—so that the family may squabble without embarrassment."

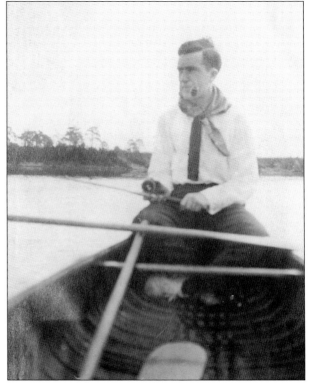

The middle child of Mina and Thomas, Charles Edison, took after his father in many ways, managing several Edison companies before becoming secretary of the Navy and governor of New Jersey. Later in life, Charles became active in preserving his father's legacy in Fort Myers. Seen here around 1915, he also enjoyed exploring and fishing in the waters of southwest Florida.

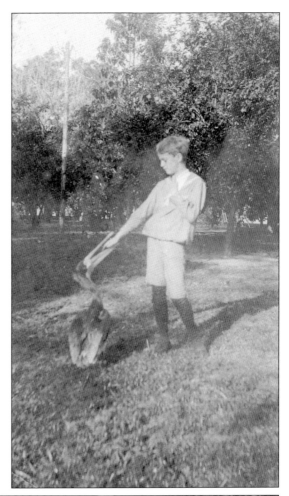

Theodore Edison, youngest child of Mina and Thomas, was a nature lover and inventor, with more than 80 patents to his credit. Seen here playing with a pelican on the grounds of Seminole Lodge around 1910, Theodore also collected baby alligators, which were released at a formal event hosted by his mother, much to the dismay of her guests. He became an environmentalist before the term entered common usage, helping to preserve land in Maine and southwest Florida. Birds such as the pelican seen at right were a common sight at the Edison winter estate; a pet peacock even roamed the grounds, seen below around 1930. (Below, courtesy of Thomas Edison National Historical Park.)

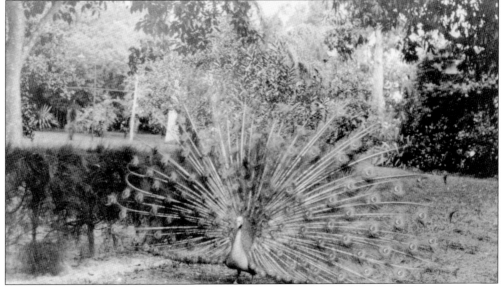

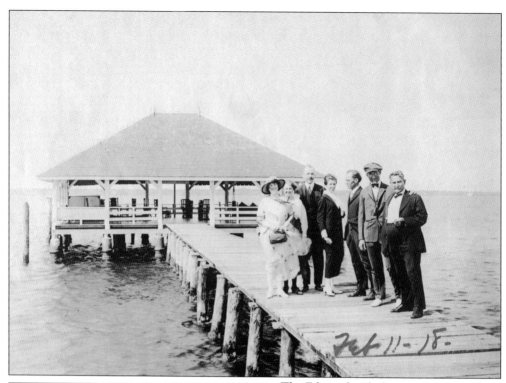

The Edison family frequently ventured into the waters surrounding their winter estate, hiring boat captains, such as the local Menge brothers, to take them on voyages. Pictured here, a group of unidentified visitors poses with machinist Fred Ott (far right) near the river pavilion located at the end of the Edison pier in 1918. Note the date in the lower right-hand corner of the photograph—it was taken on Thomas Edison's 71st birthday.

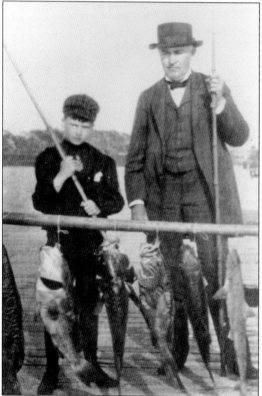

The Edison family did not have to venture far to find excellent fishing. Charles Edison, pictured here with his father around 1901, recounted a legendary fish story. He elected to fish the waters surrounding Seminole Lodge while his father boated upriver, and much to his surprise, Charles caught a "silver king" weighing more than 100 pounds, which was almost twice as large as the tarpon his father caught upriver. (Courtesy of Thomas Edison National Historical Park.)

In addition to chartering boats, the Edisons also owned several of their own vessels, which they used for fishing or simply enjoying the local waterways. Purchased in 1904 and seen here around 1910, the *Reliance* was a 36-foot electric launch powered by Edison's own storage batteries. Edison outfitted a boathouse on his pier with a charging station for the vessel's batteries. .

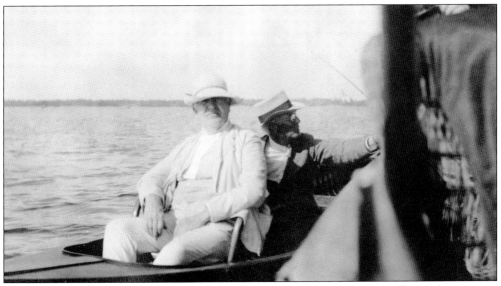

Like many vessels its size, the *Reliance* towed a smaller boat behind that could be used to traverse shallow waters and transport passengers to shore. Here, Edison and an unidentified man prepare to board the *Reliance* from the smaller vessel around 1920. Note Edison's attire—even in the warmest Florida weather, Edison was rarely seen without a formal suit.

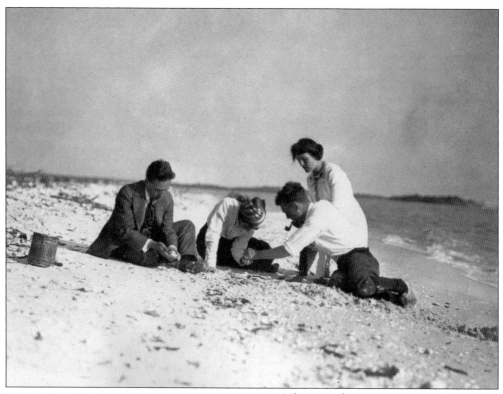

A frequent destination for the Edison family, nearby barrier islands Sanibel and Captiva afforded excellent opportunities for shelling and miles of pristine beaches. Here, Madeleine and Charles Edison, along with Edsel Ford and family friend Bessie Krup inspect shells on a local beach about 1914. Sanibel Island is still renowned for its incredible shelling today.

Theodore and Mina Edison navigate the oxbows of the Caloosahatchee River around 1906. A naturally meandering waterway with many sharp turns, the Caloosahatchee underwent significant changes as the area modernized. Dredging of swampland in the late 19th century and straightening of the river allowed for an increased pace of development, which the Edisons appreciated, but significantly altered the natural ecology of the area, which they lamented.

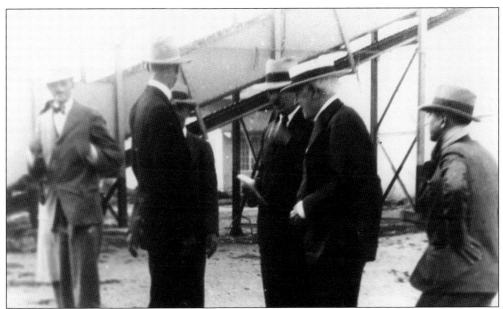

The Edison family also traveled to nearby sites of cultural and scientific interest. Above, Thomas Edison tours a Clewiston sugar factory in 1929. Inland areas around Lake Okeechobee, like Clewiston, became major sugar-producing communities in the early 20th century. Edison was particularly interested in the sugarcane crushers and rollers, which he examined in hopes of adapting for his rubber research. Both the Edison and Ford families also visited the Koreshan Unity settlement, home to a utopian religious group just south of Fort Myers in present-day Estero, Florida. The settlement featured some of the earliest bakeries, wood mills, and electrical generators in the area and hosted cultural and social events. The Koreshan Unity band can be seen below performing at the Koreshan Unity settlement. Today, this site is preserved and open to the public as a Florida state park. (Below, courtesy of Florida Memory.)

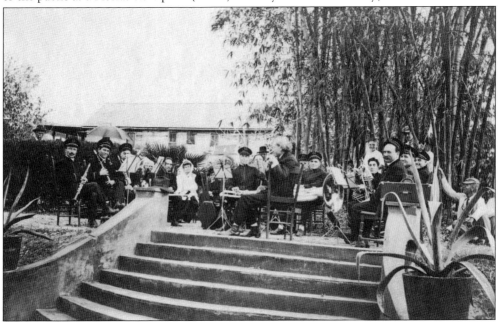

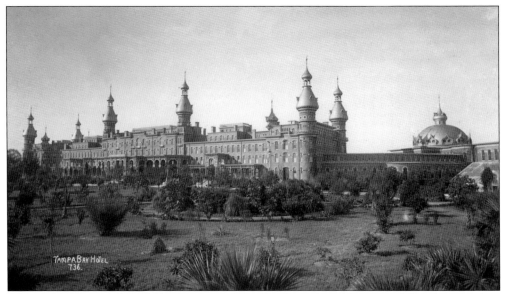

Edison's companies electrified important structures throughout the state of Florida, including railroad magnate Henry Plant's Tampa Bay Hotel, built in 1891. The Edison family stayed in the Moorish-style hotel in 1900, approximately five years after this photograph was taken. The extravagant building is now part of the campus of the University of Tampa and home to the Henry B. Plant Museum. (Courtesy of Florida Memory.)

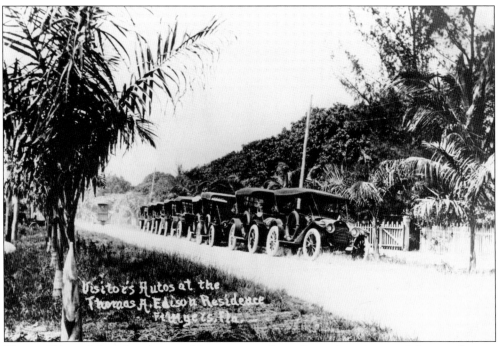

Thomas Edison did not have to travel far to meet with intellectuals and some of the most famous men and women of his era—they frequently traveled to Fort Myers for an opportunity to spend time with him. In this image, a row of automobiles lines McGregor Boulevard just outside Edison's Seminole Lodge around 1920.

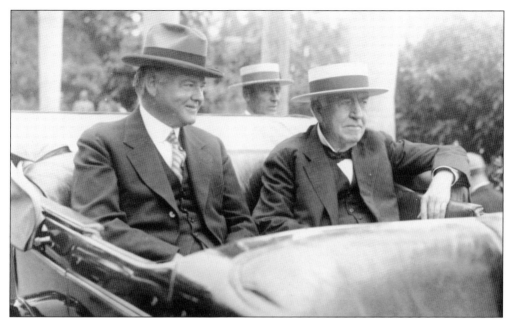

One of the famous guests of Seminole Lodge was president-elect Herbert Hoover, seen here during a parade through Fort Myers with Thomas Edison in 1929. Other guests included the Fords, Firestones, Colgates, Kelloggs, Mercks, and J.N. "Ding" Darling. Below, the Firestone and Ford families ride through downtown Fort Myers in a parade celebrating Thomas Edison's birthday on February 11, 1929. By this time, the small cow town of 349 Edison first visited in 1885 had grown to a community of almost 10,000. The cattle trade had been overtaken by the sport fishing and citrus industries, for which Florida is still well known today.

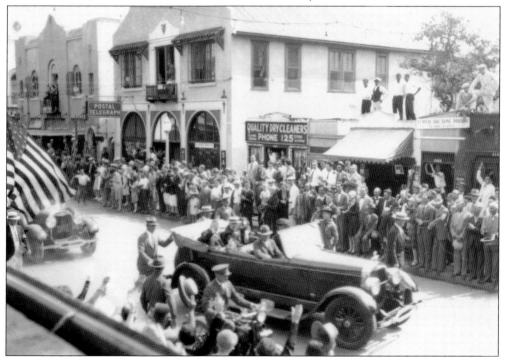

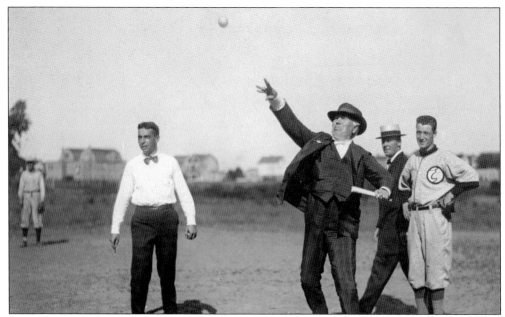

Fort Myers eventually became the spring training home for Northern baseball teams. Above, Thomas Edison throws a pitch during spring training in 1914. At one practice, Edison picked up a bat, and the local newspaper reported, "A recruit by the name of Tom Edison broke into big league company yesterday and finished his first try-out with a batting average of .500, a mark which Babe Ruth, Ty Cobb and the best sluggers of the land have never been able to reach after a whole season of endeavor." Below, Thomas and Mina pose with the Philadelphia Athletics, including stars like Ty Cobb, Jimmie Foxx, and Lefty Grove, who visited Seminole Lodge for lunch and a tour of the grounds in 1927.

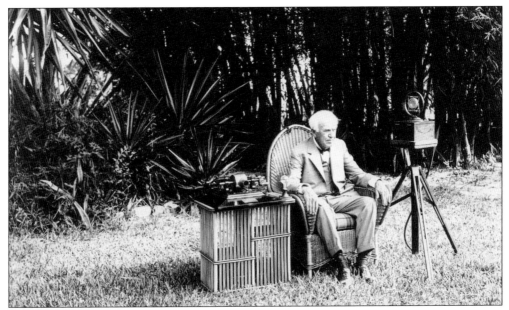

During the Edison family's time in Fort Myers, many traditions developed around them. Each year, local residents gathered to greet the family at the train station, and Edison's birthday was celebrated with a parade and further festivities. Another annual tradition was the birthday interview. Pictured here in 1929, Edison relaxes near the recently constructed Moonlight Garden, preparing for an interview with the press, who sought his opinions and witty remarks on the topics of the day.

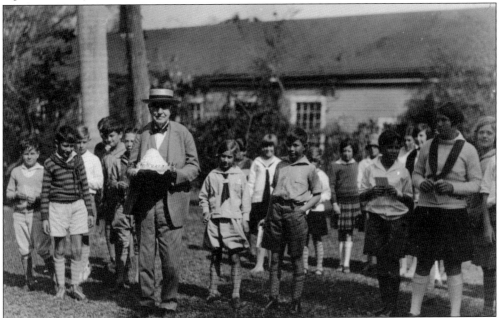

Pictured here in 1928, Thomas Edison accepts a birthday cake presented by students from a school in nearby Sarasota. During their time in Fort Myers, the Edison family hosted visiting groups of all kinds, from entertainers to students. Many visitors later remarked about the extraordinary warmth and hospitality they received at Seminole Lodge.

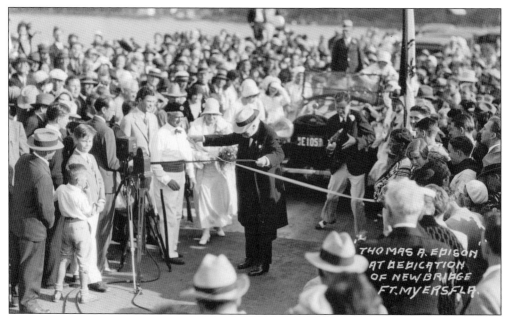

In 1931, Edison's birthday celebration in Fort Myers coincided with the dedication of the Edison Bridge, named in his honor. Edison is pictured here cutting the ribbon, symbolically opening the new bridge. Mina Edison stands to his right. Ironically, the bridge, named after the man best remembered for his work on the lightbulb, did not feature electric lights until six years later.

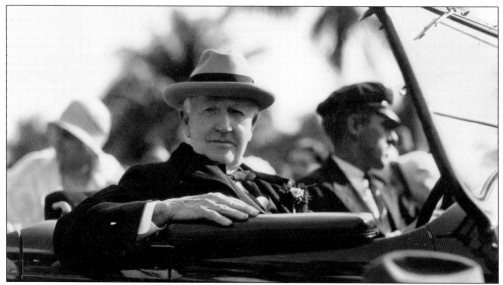

Thomas Edison's 84th birthday was the last the inventor celebrated in Fort Myers. Seen here, he rides in his annual parade through Fort Myers on February 11, 1931. Edison passed away that October, leaving behind an indelible mark on the city of Fort Myers and having shaped its development in countless ways.

Four

EDISON AND
FORD CONNECT

I can only say to you that, in the fullest and richest meaning of the term—he is my friend.

—Thomas Edison on Henry Ford, 1929

Henry Ford was born on a prosperous farm near Dearborn, Michigan, west of Detroit, in 1863. From an early age, Ford loathed the monotony of farmwork. He loved the challenge of machinery and spent countless hours disassembling and attempting to repair watches. Like Thomas Edison, Ford was a self-made man with limited formal education. By the age of 17, Ford escaped the farm and moved to Detroit. He eventually found employment at the Detroit Edison Illuminating Company. Ford's interest in mechanics served him well. In the evenings, he tinkered in his kitchen making a gasoline engine, which he eventually mounted on his "quadricycle," the first Ford car.

Only two months after completing his quadricycle, Ford met his idol, Thomas Edison, whose encouragement propelled Ford into Detroit's automobile market. In the years following the 1903 introduction of the Model A, Ford continued to make improvements on his vehicles. In 1908, he introduced one of the best-selling vehicles of all time, the Model T. What helped him succeed over the more than 150 other automobile manufacturers across the United States was the fact that his vehicles were cheaper and simpler than the competition's. At a time when a gasoline car was considered a luxury item, Ford's vehicle was affordable and practical. It was three years after Ford introduced his legendary Model T that he was reacquainted with his idol, Edison, to collaborate on a battery, starting motor, and generator. The two men's rapport developed rapidly, leading to an invitation for the automobile magnate to visit his mentor's tropical estate three years later, and a lifelong friendship ensued.

Clara Jane Bryant grew up only five miles from the Ford family farm. The eldest daughter among nine siblings, Clara helped raise her brothers and sisters. When Ford returned to the farm after his grandfather died in the early 1880s, he met Clara at a harvest-moon dance. He told his sister that he knew Clara was the girl of his dreams within 30 seconds of meeting her, and they were married in 1888.

Edsel Ford was born in 1893, the only child of Henry and Clara. In 1915, Edsel married Eleanor Clay, and they had four children of their own. Edsel assumed presidency of the Ford Motor Company in 1918, when he was only 25 years old. However, Henry retained de facto control and often disregarded or reversed his son's decisions. (Courtesy of the Library of Congress.)

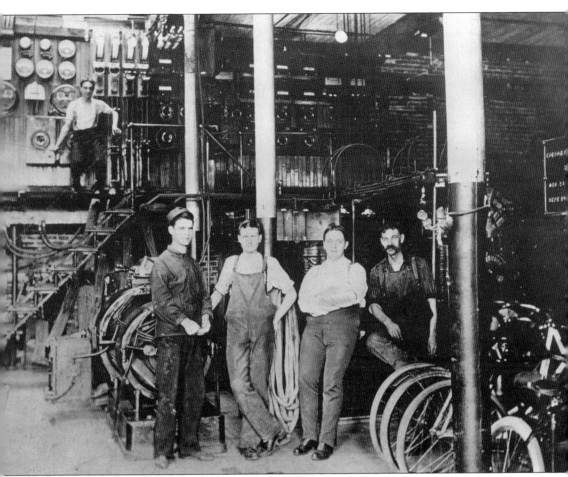

After their marriage, Henry and Clara Ford settled on land given to them by Henry's father, William. They cut and sold the timber on their property using a steam-powered circular saw. As Henry said, within two years, the trees were gone, and the big city beckoned. Henry approached Clara about his desire to move back to Detroit with all of its opportunities. She eventually agreed; this is one of the reasons why Henry called her the "Believer," commenting, "I often consult with my wife with regards to business affairs because I know her judgment is good, and many times I take her advice." In 1891, Henry Ford gained employment at the Detroit Edison Illuminating Company, Detroit's leading producer of electrical power. Here, Ford is seen at the electrical plant on the far right, about 1895. The ambitious and hardworking Ford soon rose to the position of chief engineer. It was a dubious honor, however, as his predecessor had been killed on the job. (Courtesy of the collections of The Henry Ford, P.188.606.)

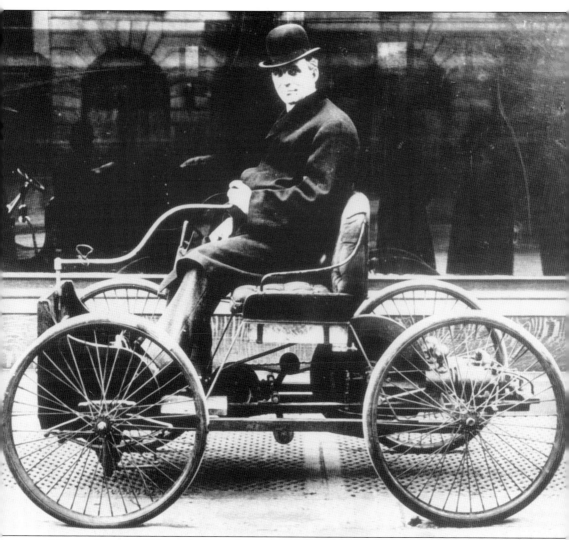

After working his 12-hour shifts at the plant, Ford returned home to continue tinkering with his four-cycle gasoline engine. Ford's engine took two people to operate, so on Christmas Eve of 1893, he dragged his equipment into the kitchen, where Clara was busy making Christmas dinner for the next day, and enlisted his wife's help. On the second try, the little engine coughed to life and began to run. It also began to belch out thick, foul-smelling black smoke and filled the house with noise. It was a success. After completing his engine, Ford moved to the next step—a vehicle. He mounted four bicycle tires to a light chassis over which he fitted his engine. As he prepared to roll his quadricycle, seen above, out of the workshop, he realized that it was too big to fit through the doorway. Ford took an axe to the doorframe, widening it until it was large enough for the vehicle to be rolled out onto the streets of Detroit and into history. (Courtesy of Ford Motor Company, New York Public Relations Office.)

In 1896, Ford was invited to the annual convention for Edison's Illuminating Companies, where he had the opportunity to meet his idol, Thomas Edison. After Ford's quadricycle was mentioned, Edison began firing questions at the young man. After hearing his responses, Edison slammed his fist on the table and shouted, "Young man, that's the thing! Keep at it." The famous inventor's encouragement prompted Ford to venture into automobile manufacturing.

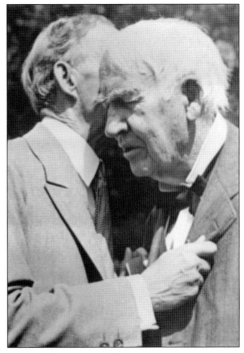

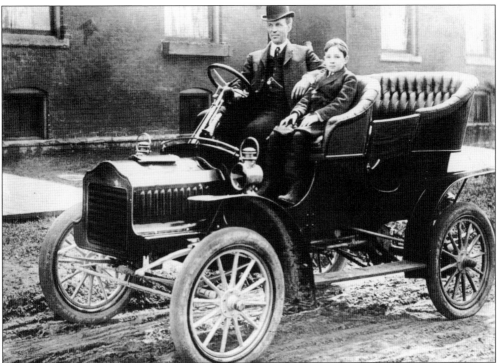

Henry and Clara Ford had their only child, Edsel, in 1893. He is seen sitting here with his father around 1904. Henry worked his way through the developing automobile field, helping to start three different companies. Through Edsel's young life, Henry moved the family into at least 10 different rented dwellings before completing their permanent home, Fair Lane, in 1915.

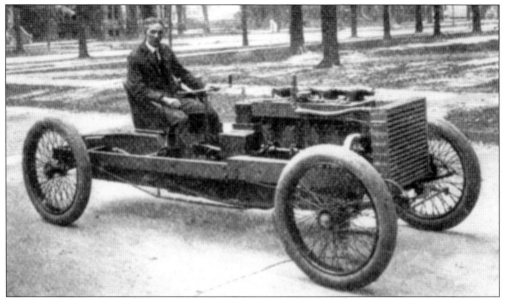

To gain investors, Ford needed to stand out from other fledging automobile manufacturers. A racing championship nearby offered the opportunity. The only other entrant was the most famous racer of the day, who shot ahead of Ford at the start, but suffered engine trouble. Ford flew past and won the championship at a blistering 45 miles per hour. His engineering skills and newfound fame soon attracted investors to his company. (Courtesy of Florida Memory.)

In 1904, Henry Ford completed construction on the Piquette Avenue Plant, a state-of-the-art manufacturing facility, seen here. In this factory, workers labored up to 12 hours to construct a single vehicle. It was not until 1913 that Ford introduced the assembly line into his next factory and was able to drop manufacturing time to only two hours and 30 minutes, resulting in a much less expensive product.

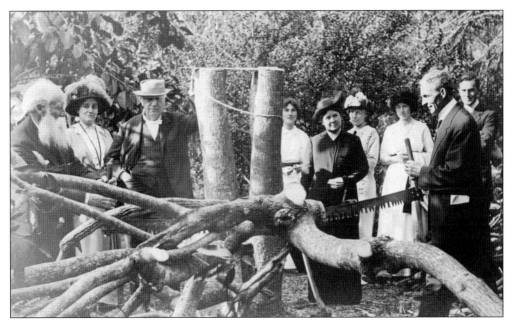

After not communicating for more than a decade, Ford reached out to Edison, and the pair collaborated on engine components in 1912. Henry Ford and his friend John Burroughs were invited to Seminole Lodge two years later. Here, Burroughs and Ford cut a tree in Fort Myers as, from left to right, Mina, Thomas, and Madeleine Edison, Clara Ford, two unidentified individuals, family friend Bessie Krup, and Charles Edison look on. Ford was known to challenge friends and employees to feats of strength.

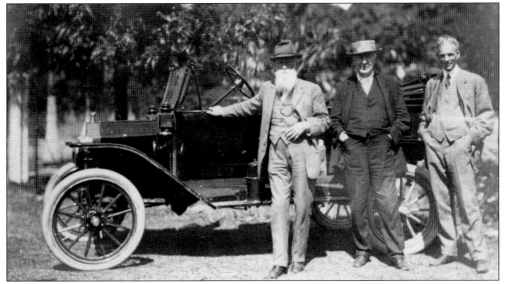

By 1914, Ford and Edison's entrepreneurial quest to produce new products led to a decade of exploring American resources with their friend John Burroughs. Burroughs, a famous author and naturalist, was initially horrified by the "foul incursions" of the automobile into nature. Ford, a fan of Burroughs, successfully convinced him that the car allowed average Americans to escape an urban environment and experience the natural world. Pictured are, from left to right, Burroughs, Edison, and Ford.

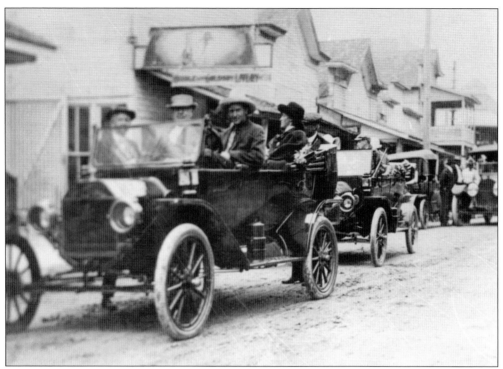

The first of the many camping trips taken by the "famous friends" over the years left Seminole Lodge for several days of camping in the Everglades in 1914. Above, the group prepares to leave from downtown Fort Myers. It first traveled to the nearby town of LaBelle and then along the Caloosahatchee River before turning south into the Big Cypress Swamp. Charles Edison recalled that once they left the surroundings of Fort Myers there were no roads, as can be seen in the image below. At first, only the men were invited, but Mina objected, so she, Madeleine, Charles, and Theodore Edison, Clara and Edsel Ford, family friends Bessie Krup and Lucy Bogue, and three guides accompanied the expedition. (Above, courtesy of the Southwest Florida Historical Society.)

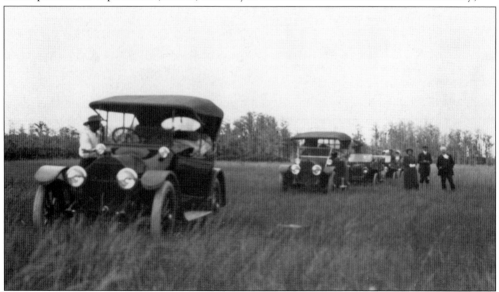

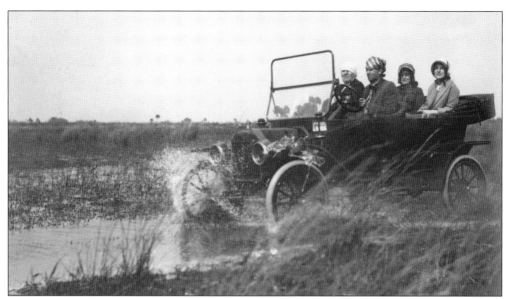

At one point on the trip, the group reached a wide pond. When Charles was told to drive across, he asked how he would find the high spots. The guide replied, "Well, you just have to feel your way." They managed to cross the quarter-mile-wide pond without incident. Pictured above are, from left to right, Thomas, Charles, Mina, and Madeleine Edison. Below, Thomas, Mina, Charles, and Madeleine Edison, Henry and Clara Ford, John Burroughs, Bessie Krup, Lucy Bogue, and two of the guides relax around the campfire during their 1914 camping trip.

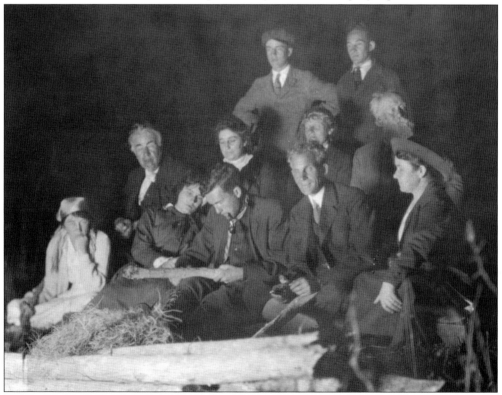

After reaching their camping site, Henry Ford and Charles Edison found an abandoned boat and paddled into a nearby lake. As they rowed, they noticed several snakes. Ford pulled out his .22 target pistol, and Charles credited him with being able to hit a snake from 25 feet away. One of the guides also shot a turkey for dinner, which may be the one Ford holds here.

One evening, the group was doused by a heavy downpour, leading Charles Edison to write a short poem: "Consumption, pneumonia and grip, Will be the result of this trip, We'll all die together, From the inclement weather, On the doormat of Heaven we'll drip." Bessie Krup refused to leave her tent until her clothes were dried, so Henry Ford put up a makeshift clothesline, seen in the background of the photograph.

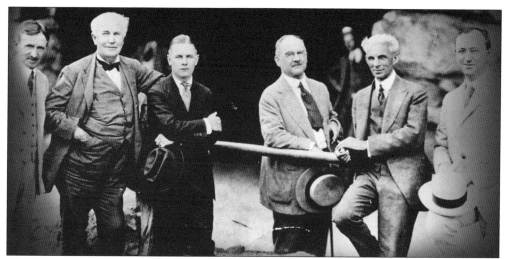

This rain-soaked trip did not prevent Edison, Ford, Burroughs, and their friend Harvey Firestone, a tire manufacturer, from continuing to take camping trips into the 1920s. Their trips would take them through the Northeast, the Mid-Atlantic, and even to California. In 1918, the group traveled from Pennsylvania south to North Carolina. From left to right, Firestone, Edison, two unidentified men, Ford, and another unidentified man are seen at the Grove Park Inn in Asheville, North Carolina.

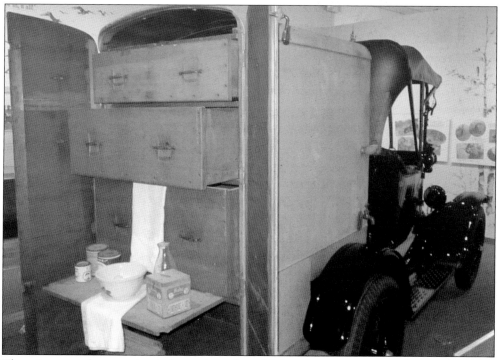

The trips started out as simple forays into the wild, but they grew more and more elaborate. Soon, reporters, friends, laborers, and cooks joined the men. This Model T Roadster, today on display in the Edison & Ford Winter Estates museum, was modified for camping trips. It features an aluminum-covered pine box for transporting camping supplies such as linens and utensils, in addition to food.

Henry Ford and Thomas Edison were born 16 years apart, and their friendship was more like a father and son relationship in some respects. Ford idolized his friend, saying, "In my opinion Edison to-day is the top man of the world. He is the man who has done the most for it." Edison is seen here reading a newspaper, while he smokes a cigar, one of his few vices. In 1890, Edison proclaimed, "I am a great smoker and smoke from 10 to 20 strong cigars a day." Ironically, both he

and Ford abhorred cigarettes, and Edison even wrote, "I employ no man who smokes cigarettes." They even collaborated on a book discussing the dangers of cigarette smoking. Edison and Ford were similar in many other ways, especially in their attitudes toward hard work, their empirical learning styles, and their steadfast belief in trying to improve people's lives through their inventions and innovations. Together, these two American icons held 1,254 US patents.

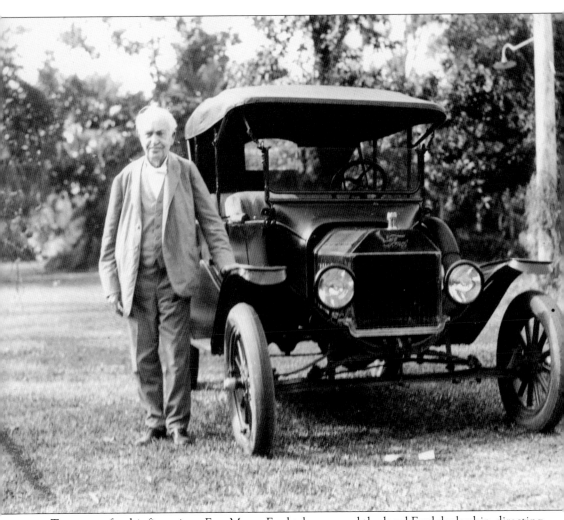

Two years after his first trip to Fort Myers, Ford telegrammed the local Ford dealership, directing it to present Edison with a new Model T for his birthday. The dealer responded that he had delivered a touring car to the Edison estate and received a check for $482.75. Ford replied that it was a birthday gift and directed the embarrassed dealer to refund Edison's money. Edison used the vehicle throughout his time in Fort Myers. Over the years, Ford asked Edison if he would like a new vehicle, but each time, Edison responded that his worked just fine. So every few years, new features were added to the vehicle, and it was returned to Edison. The car is now on display in the Edison & Ford Winter Estates museum. The Edisons continued inviting the Ford family to visit them at Seminole Lodge, and in 1916, the same year this car was presented to Edison, the neighboring estate came up for sale.

Five

FORD COMES TO FLORIDA

Without doubt, Thomas Edison is my greatest contemporary.

—Henry Ford on Thomas Edison, 1928

The famous friendship between Henry Ford and Thomas Edison had its origin in their shared interest in innovative design but truly solidified around the time of World War I. In 1911, New York entrepreneur Robert Smith built a Craftsman bungalow on the property adjacent to Thomas Edison's Fort Myers estate. At the same time, Ford and Edison were corresponding by mail, and in 1914, they took a fateful camping trip together. Along with tire tycoon Harvey Firestone and naturalist and author John Burroughs, they become known as the "four vagabonds," traveling the back roads and countryside of America over the next decade. Robert Smith noted that Henry Ford lodged at Thomas Edison's Guest House and wrote to the famous automobile magnate, inquiring if he would like to purchase his estate. Ford, who by this time had become a self-made millionaire, purchased the home in 1916, becoming the neighbor of his friend and mentor. Fort Myers residents were ecstatic—two of the most famous and universally celebrated American innovators were now wintering in sleepy southwest Florida. The following year, Ford began an annual tradition that he would continue until Edison's death in 1931, visiting Fort Myers to help his famous friend and mentor celebrate his birthday. During their time in Fort Myers, the Ford and Edison families became closely intertwined, both with each other and with the people of Fort Myers. Most importantly, the time that Henry Ford and Thomas Edison spent together in Fort Myers helped to strengthen their relationship and bring two of the world's greatest innovators closer together.

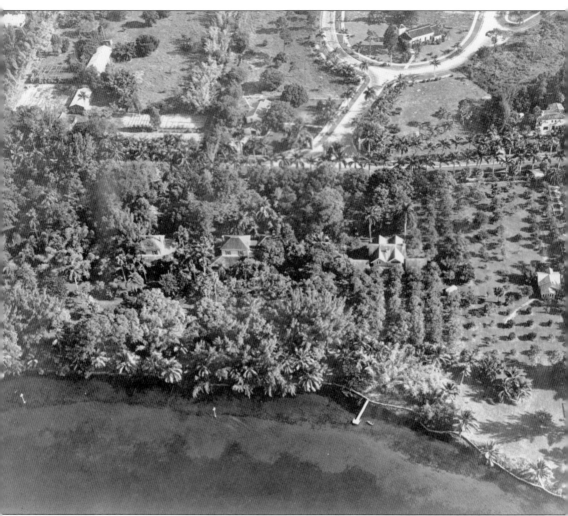

In this aerial view of the Edison and Ford winter estates around 1920, Edison's Main House and Guest House are visible at left, and Henry Ford's metal-roofed home is visible at right. The circular drive at the top of the photograph is the entrance to Edison Park, a subdivision named after the famous inventor. The building at the entrance to the subdivision is a church, later named for Thomas Edison as well. Also seen are Edison's utility structures, including a barn, across McGregor Boulevard. Other recognizable landscape features include the purple martin birdhouses in the river and the dock in front of the Ford home. In 1886, Edison completed construction of his home a mile outside of town. As can be seen here 35 years later, very few neighbors encroached on his privacy.

Like Edison, Ford, pictured here around 1919, experienced tremendous success, which brought its own set of problems, including stress and a lack of privacy. Unlike Edison, who often enjoyed talking with the media, Ford disliked the paparazzi and relished the peace Florida offered. Ford would even disembark from the train a mile outside of Fort Myers so that he could avoid the crowds of well-wishers at the train station.

Pictured here around 1953, Fair Lane, the year-round residence of the Ford family, was located in Dearborn, Michigan. Ford's northern home was much more ornate than the simple Craftsman bungalow he purchased in Fort Myers. The estate had three large greenhouses, a swimming pool, bowling alley, small golf course, and its own hydroelectric power plant, driven by the Rouge River. (Courtesy of the collections of The Henry Ford, P.O.1185.A.)

In 1916, Henry Ford received a letter from entrepreneur Robert Smith, offering to sell him his home adjacent to the Fort Myers estate of Thomas Edison for $25,000. Smith noted that the grounds featured over 100 fruit trees. In fact, the property was named the Mangoes after the line of the trees that ran along McGregor Boulevard. Note the stand of bamboo pictured here around 1916—it still thrives today.

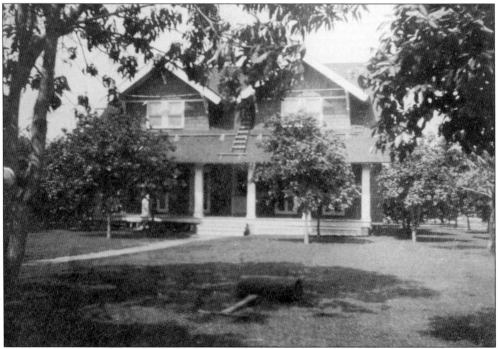

Included with Smith's letter were several images of the property taken from 1911 to 1916. This photograph of the Mangoes, under construction around 1911, may have been included. Ford countered the asking price with an offer of $20,000, which Smith eventually accepted. The agent brokering the sale sent a telegram to Ford, which ended with "three cheers" for the small town's newest celebrity resident.

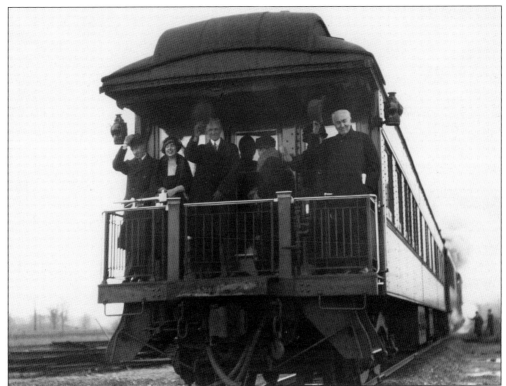

For the first two decades he visited Fort Myers, Edison had to travel by boat. By the time he purchased his home, Henry Ford was able to travel in comfort in his personal railcar, *Fair Lane*. Pictured here are, from left to right, Edsel Ford, Eleanor Ford, Henry Ford, two unidentified individuals, and Thomas Edison aboard the *Fair Lane* about 1923. Today, the railcar is preserved at Greenfield Village. (Courtesy of the collections of The Henry Ford, P.O.961.)

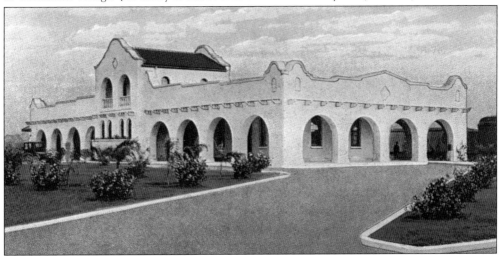

The railroad did not reach Fort Myers until 1904, significantly later than many parts of the country. When early visitors traveled by rail to Fort Myers, they disembarked at the Atlantic Coast Line railroad station, seen here around 1925. Today, this structure serves as the Southwest Florida Museum of History. (Courtesy of Florida Memory.)

Ford's Fort Myers estate was lushly landscaped with mango trees and oleanders, as seen in this image from about 1916. The home was built to withstand the hazards of Florida's climate—due to concerns about high winds, all supporting timbers for the home were doubled, prompting original owner Robert Smith to describe the house (in a personal letter) as "the best built structure in Fort Myers."

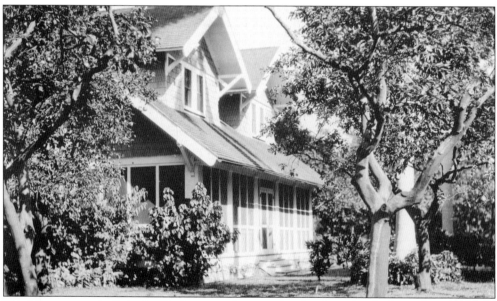

The Mangoes was built in the Craftsman architectural style. Considered a bungalow, the home has a low-pitched gable roof, conspicuous porch columns, and prominent use of natural building materials, which are showcased in the architectural design. The home was originally roofed with cedar-shake shingles, which Ford later replaced with tin shingles.

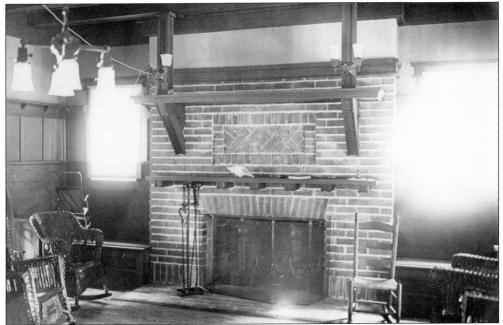

Craftsman features continue inside the home, with visible ceiling beams and woodwork throughout the living room. The home was constructed of Florida cypress and pine. Built-in features such as the double mantle and corner benches seen in this image, taken about 1925, were both decorative and practical. Interestingly, this is one of the few historical interior photographs of the Mangoes or Seminole Lodge that are known to exist. (Courtesy of the collections of The Henry Ford, P.O.15661.)

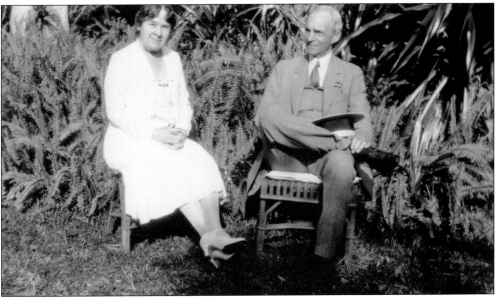

Henry and Clara Ford relax in Fort Myers around 1925. Perhaps helping to explain the lack of interior images, both the Edison and Ford families largely saw Fort Myers as a place to escape to the outdoors. The Fords were avid bird-watchers, as this was a hobby they were able to enjoy both at their year-round Michigan residence and especially in Florida.

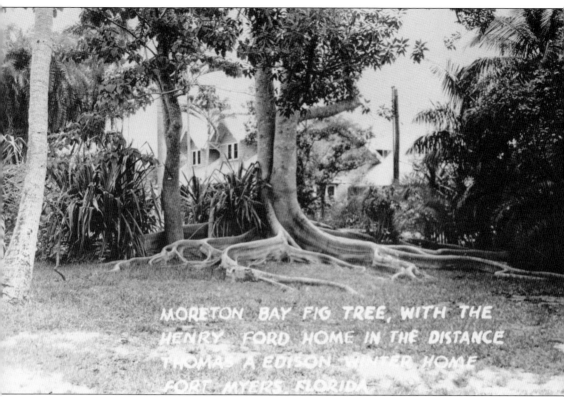

MORETON BAY FIG TREE, WITH THE
HENRY FORD HOME IN THE DISTANCE
THOMAS A EDISON WINTER HOME
FORT MYERS, FLORIDA

This view from the Edison property around 1955 shows a stately Moreton Bay fig tree with the Mangoes seen in the background. It is likely that it was planted around the same time as other potential rubber-producing trees, like the banyan tree, Mysore fig, and other ficus trees. The "friendship gate" that joined the two friends' properties had to be moved several times due to this tree's sprawling root system. When Ford acquired his property, he kept many of its unique plants and trees, including 100 grapefruit trees, 50 orange trees, a variety of mango, pawpaw, lemon, lime, guava, tangerine, coconut, and banana trees, and a vegetable plot.

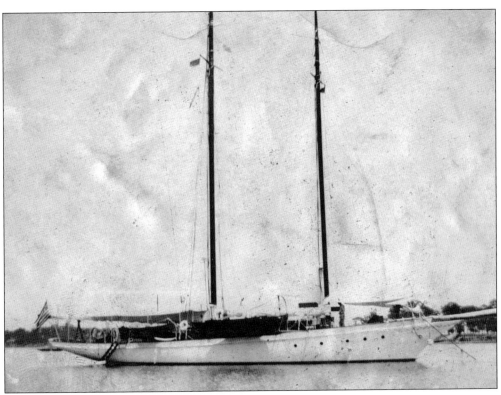

Ford did not always travel to Fort Myers by rail. In 1917, he ventured south aboard the above yacht, the *Sialia*, on a trip to Cuba, stopping in Fort Myers along the way. Because the Caloosahatchee River was so shallow, he had to anchor at its mouth. On his return, the US Navy purchased his vessel for use during World War I, but Ford later reacquired it.

Typically, Henry Ford traveled to Fort Myers with his wife, Clara, and only son, Edsel, who is pictured here standing on the Edison dock, near the river pavilion, about 1915. Edsel enjoyed his visits to Fort Myers and became close friends with the Edison family, particularly Madeleine and Charles.

Madeleine Edison paints near the boathouse, located on the Edison dock, as Edsel Ford (left) and Charles Edison look on, about 1915. Time spent in informal Fort Myers, away from the expectations that came with being the children of American icons, was important to the Edison and Ford children. Charles and Edsel followed in their fathers' footsteps, serving as president of their respective companies.

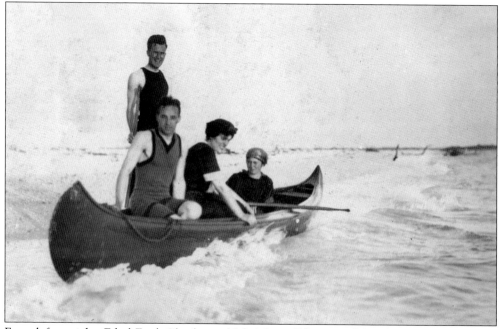

From left to right, Edsel Ford, Charles and Madeleine Edison, and family friend Bessie Krup beach their canoe on a southwest Florida island around 1915. Under Edsel's leadership, the Ford Motor Company introduced innovative safety features, modernized vehicle designs, and made key military contributions during World War II.

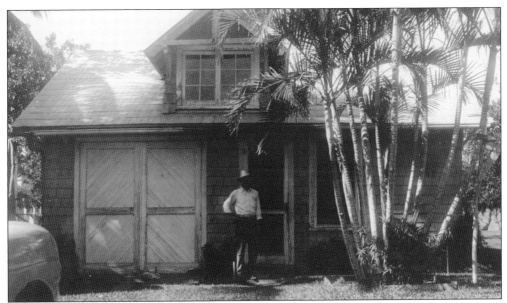

This structure, on the south end of Ford's Fort Myers estate, served as a garage and residence for the year-round caretakers, shown here around 1945. According to a Ford employee, this building was also used to conduct secret experiments on early V-8 engines. Ford employees also conducted experimental work on the V-8 in Thomas Edison's original 1886 Fort Myers laboratory, which at that point was located at Henry Ford's Greenfield Village. (Courtesy of the collections of The Henry Ford, P.O.15662.)

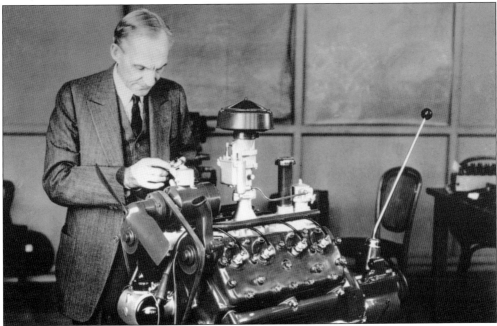

In 1932, Henry Ford inspects the first V-8 engine, which he developed to outperform the competition's V-6 engines, during its commercial debut. The V-8 got its name from the eight cylinders inside the engine block and was cast from a single block of iron. (Courtesy of the New York Public Relations Office, Ford Motor Company.)

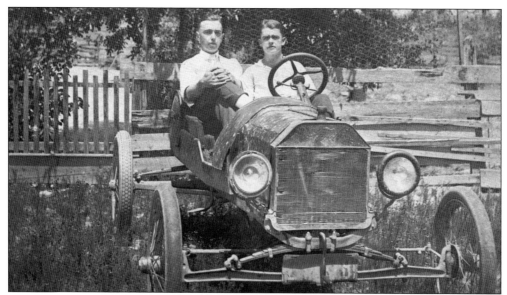

Ironically, Ford's tiny Fort Myers garage contained only one car. Driving an automobile in southwest Florida was often difficult, because the rough roads were better suited for wagon traffic. This image, taken about 1915, illustrates how Florida drivers adjusted to their surroundings—axles of automobiles, such as this Model T, were widened an additional four inches so that the vehicle's wheels would fit in the wagon ruts. (Courtesy of Florida Memory.)

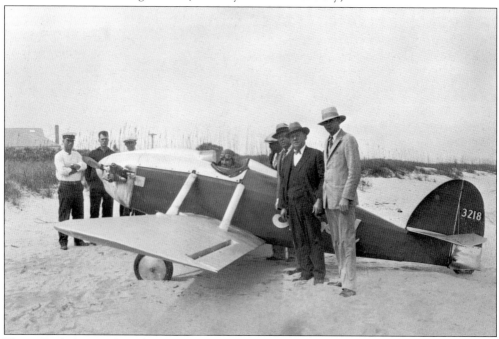

Henry Ford also conducted experiments related to aviation in Florida. Ford tested his Flivver, a small, lightweight plane known as the "Model T of the Air," seen here on a Florida beach in 1928. During World War II, Ford factories constructed urgently needed B-24 Liberator bombers. Due to his many contributions to the industry, Ford was inducted into the National Aviation Hall of Fame. (Courtesy of Florida Memory.)

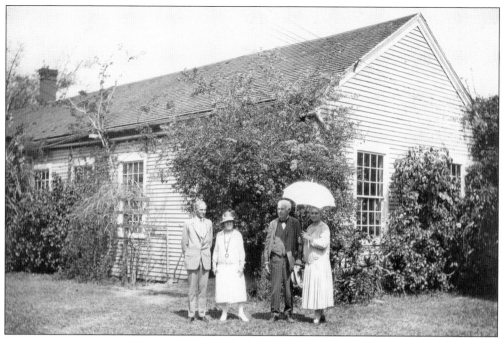

In the late 1920s, Henry and Clara Ford began an ambitious project, collecting and relocating significant American buildings to a site called Greenfield Village. When the Edisons were approached about relocating the 1886 Fort Myers laboratory, Mina was initially dismayed, wanting the structure to remain in Fort Myers. Eventually, she agreed, and the lab was dismantled in 1928, shortly after the above photograph was taken. Below, workers disassemble the 1886 Fort Myers laboratory in preparation for moving it. The laboratory is still on display at Greenfield Village today. In return for agreeing to move the building, Henry Ford financed a number of additions to the Edisons' Fort Myers property, including a study, the Moonlight Garden, the tea house, and a portion of the Edison Botanic Research Corporation laboratory. (Below, courtesy of Thomas Edison National Historical Park.)

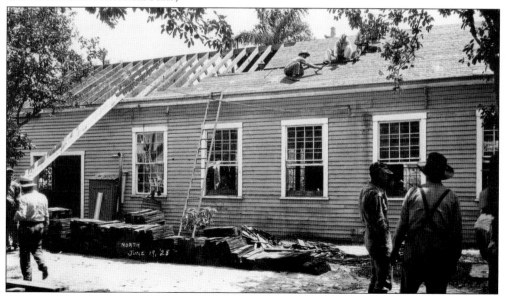

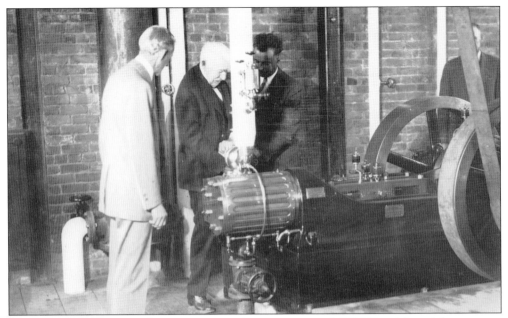

Edison and Ford inspect the generator in the reconstructed 1886 Fort Myers laboratory at Greenfield Village. Because the first structures brought to Greenfield Village were all related to Thomas Edison, it was originally known as the Edison Institute. In 1929, the site was opened to special guests to commemorate the 50th anniversary of the completion of Edison's improved incandescent lightbulb.

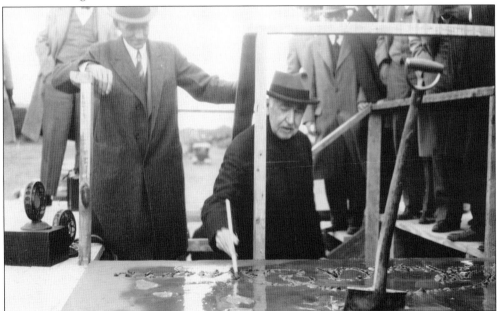

Henry Ford looks on as Thomas Edison signs his name in cement to dedicate Greenfield Village in 1929. Dignitaries such as Pres. Herbert Hoover and John D. Rockefeller were in attendance to witness the momentous occasion. Edison and Ford's historic friendship did not end with the opening of Greenfield Village—the two great innovators still had much to accomplish together, including the project that would become Edison's last.

Six

RUBBER,
THE FINAL PROJECT

Florida will manufacture rubber yet.

—Thomas Edison, 1925

By the turn of the 20th century, American industry had developed a need for rubber, originally tapped from wild rubber trees throughout the Brazilian rainforests. By the 1920s, the British Empire had established rubber tree plantations in Asia and produced a majority of the world's rubber. With synthetic rubber still decades away, America was fueled by natural rubber and consumed over 70 percent of the world's production. In an attempt to bolster the British economy, rubber exports were restricted in 1922, and the price rose dramatically, from 12.5¢ per pound to $1.23 per pound by 1925. The rapid price increase affected industrialists like tire tycoon Harvey Firestone and automobile magnate Henry Ford as well as Thomas Edison, who used rubber in a variety of products. The unstable price also presented a national-security concern, as the US military needed rubber for tires for military vehicles and equipment such as gas masks and boots.

In 1927, Edison, Ford, and Firestone united to find a natural source of rubber that could be grown in the United States. Critical to their search was finding a plant that could be grown quickly, in the case of an emergency like war. The following year, a laboratory was built in Fort Myers that served as the headquarters for the Edison Botanic Research Corporation (EBRC). Over 17,000 plant samples were tested in the search, which became the last major project of Edison's life. Despite devoting considerable resources to finding a natural source of rubber, Edison passed away in 1931, before the project could be brought to an industrial level. In his quest for rubber, the systematic approach to invention that characterized Edison's entire career can be seen, as can the collaborative nature of his decades-long friendship with Henry Ford. The project would have lasting scientific repercussions, which can still be seen today in organic chemistry and rubber research.

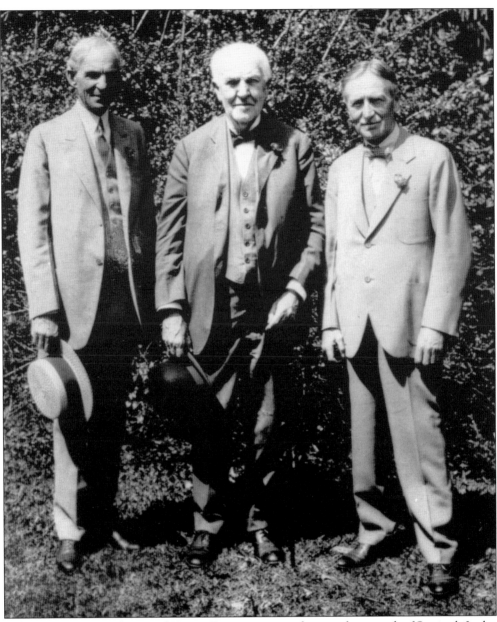

Henry Ford, Thomas Edison, and Harvey Firestone are seen here on the grounds of Seminole Lodge around 1920. The famous friends enjoyed camping trips together and were also dynamic innovators in their respective fields. The rapidly increasing price of rubber was of vital consequence to Ford and Firestone, who began searching for international rubber-growing locations. Ford unsuccessfully attempted to start a rubber plantation in Brazil, while Firestone looked first to the Philippines and later to Liberia. Firestone mentioned the topic to Edison while sitting around the campfire in 1919: "I was astounded at the knowledge of rubber that he had at hand. He told me more than I knew and more than I think our chemists knew, although to the best of my knowledge, Mr. Edison had never given any attention to rubber, except in connection to his talking machines (phonographs)." Edison pioneered a process to quickly identify potential rubber-producing plants and chemically separate the white, sticky, rubber-containing sap from the plant material.

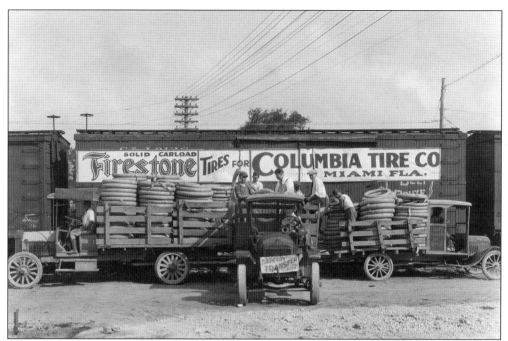

Harvey Firestone formed a tire company in Akron, Ohio, in 1900 and became one of the first global makers of automobile tires. Firestone provided the tires for millions of Model Ts his friend Henry Ford produced and later met Thomas Edison through him. Firestone tires are seen here being unloaded from a railcar into delivery trucks near Firestone's Miami Beach, Florida, home around 1921. (Courtesy of Florida Memory.)

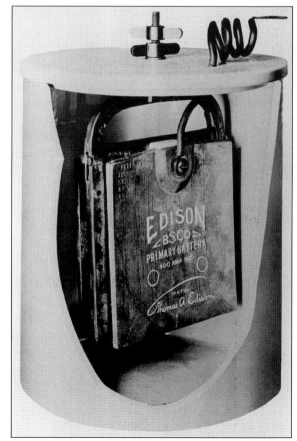

It may be obvious why Ford and Firestone were interested in rubber, but in addition to his concerns for national security, Edison's most lucrative product over the second half of his career also required rubber—the improved storage battery. The interior components of the storage battery incorporated both rubber and metal plates. Storage batteries could be recharged over and over, unlike primary batteries, which could only be used once.

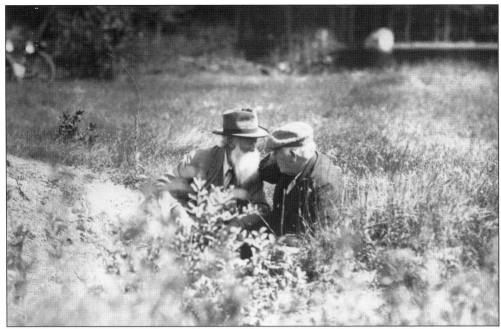

One of the many topics Edison, Ford, and Firestone discussed during their camping trips was rubber. Edison also mined his friend John Burroughs's knowledge of plants and the natural world. Burroughs (left) and Edison are seen here inspecting plant life on a camping trip in 1916. Due to his severe hearing loss, Edison holds his hand to his ear to better hear Burroughs.

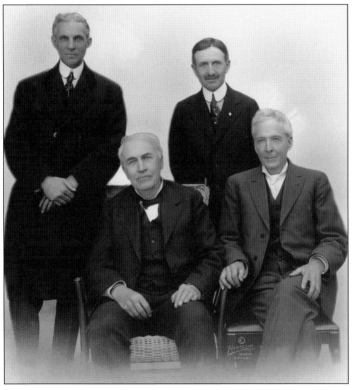

In 1915, (from left to right) Henry Ford, Thomas Edison, and Harvey Firestone traveled to the Panama-Pacific International Exposition in San Francisco and met with the acclaimed "Wizard of Plants" Luther Burbank (far right). Burbank introduced more than 800 new varieties of plants to the world, including over 200 varieties of fruits, many vegetables, nuts and grains, and hundreds of ornamental flowers. Burbank shared some of his hybridization and cross-pollination techniques with Edison.

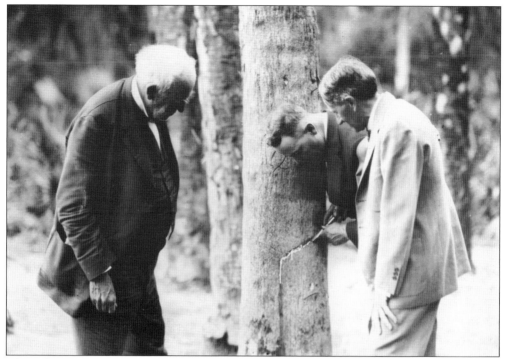

Edison (left) and Firestone look on as Firestone's assistant M.A. Cheek taps a rubber-producing tree. Edison sought a less labor-intensive method to produce natural rubber, so he began experimenting with smaller bushes and plants. He felt synthetic rubber was years from being a practical product, so he dedicated his research to finding an alternative source of natural rubber. (Courtesy of Thomas Edison National Historical Park.)

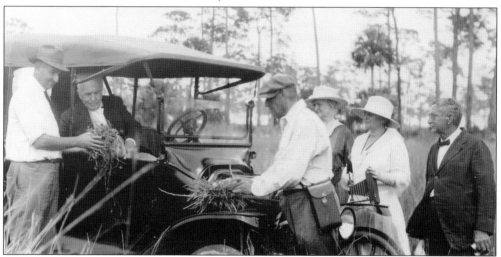

Here, Edison examines some potential rubber-producing plants that his friends the Menge brothers are holding. Pictured, from left to right, are one of the Menge brothers, Thomas Edison, another Menge brother, Edith Potter, Mina Edison, and Fred Ott. In addition to performing laboratory work, Edison personally searched southwest Florida for plant specimens, and staff and acquaintances sent plant samples from all across the world. Edison was even known to question unsuspecting citizens about plants which might contain rubber in their area.

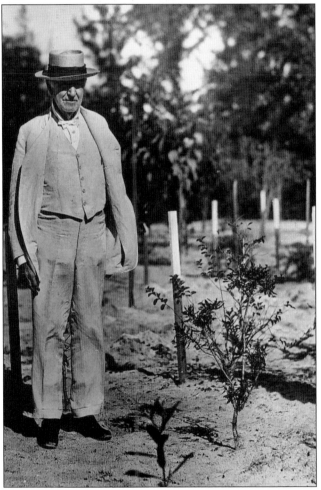

By 1927, extensive research and experimentation on the subject of natural rubber had been completed. That year, Edison, Ford, and Firestone each contributed $25,000 to form the Edison Botanic Research Corporation. The following year, this state-of-the-art laboratory was built in Fort Myers. It featured a similar layout to Edison's other laboratories in Menlo Park and West Orange, New Jersey.

Inside the newly constructed laboratory, chemicals were used to separate rubber from plant matter. However, work that was equally as important took place in the fields surrounding the structure. Edison and his staff planted a variety of specimens and experimented with different methods of fertilization and irrigation. He also cross-pollinated the plants to achieve larger specimens with higher levels of rubber content. (Courtesy of Thomas Edison National Historical Park.)

While Ford (left) and Firestone (right) stayed abreast of the project and continued to provide funds, Edison quickly became the driving force. He commented in 1927, "Henry Ford is a sort of partner of mine in this business, and we're going to work together on the experiment. I hope that I will be able to drive the first Ford equipped with tires made from the domestic rubber out of the shops before so very long."

Edison had revolutionized the process of inventing by gathering intelligent men with diverse skills to collaborate on a range of projects. He continued this approach, as over 80 staff members contributed to the quest for American rubber, including gardeners, machinists, chemists, linguists, glassblowers, clerks, and a cadre of plant explorers. Edison and his chemists were soon spending up to half the year in Fort Myers focused on the rubber research. (Courtesy of Thomas Edison National Historical Park.)

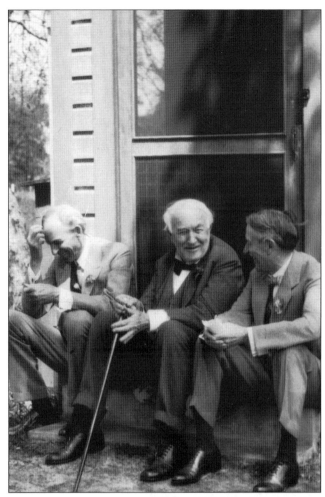

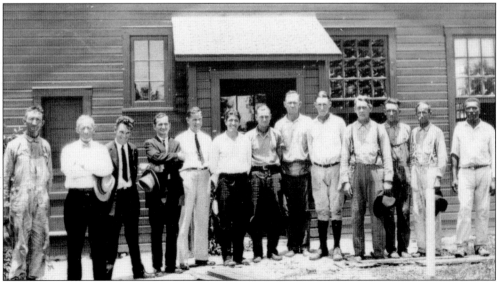

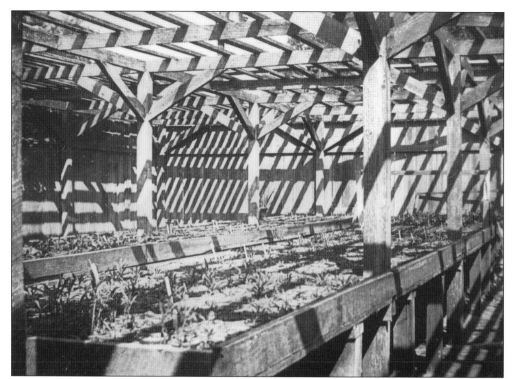

In addition to the laboratory, many other structures were built across the site, including a concrete vault, drying shed, garage, and slat houses like this one. Delicate seedlings were propagated in the slat house before being planted in the fields. Thousands of plants could be grown inside of the slat houses at one time. Shade structures like these helped extend the growing season into Florida's searing hot summer, similarly to how greenhouses keep plants warm in cooler Northern climates. Below, a worker plants specimens in a freshly prepared research bed adjacent to the laboratory. Employees carefully monitored the growing conditions of each bed.

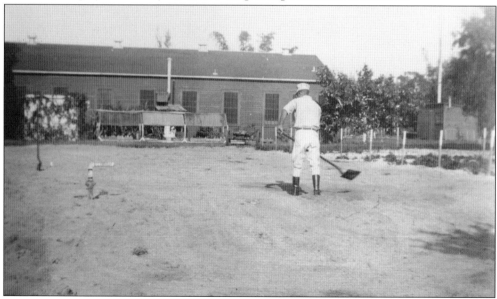

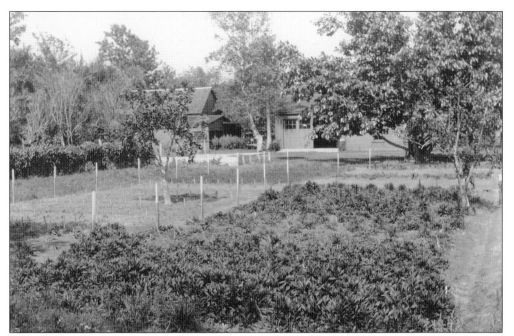

The laboratory was surrounded by acres of research beds, such as this one, where potential rubber-containing plants were grown. On the right side of this photograph, the most famous botanical specimen on the site, the banyan tree, can be seen. Today, this banyan tree is believed to be the largest example of its species in the continental United States.

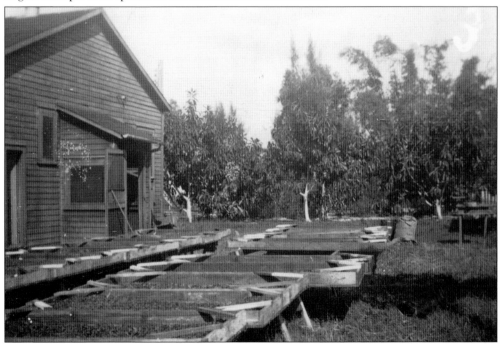

The first step in preparing the plants for chemical processing was drying. Pictured here, plant material is sun-dried on beds just behind the laboratory. A drying shed was also located in this area, and the oven located inside the shed could also be used to dry plant material.

Once dried, plant material was brought inside the laboratory, and the leaves, stems, or roots were ground into a fine powder. Note the porcelain ball mills shown in this contemporary photograph of the restored laboratory. These mills were part of Edison's 1,090th patent, a 10-step method for grinding the difficult-to-break-down portions of plants, such as stems.

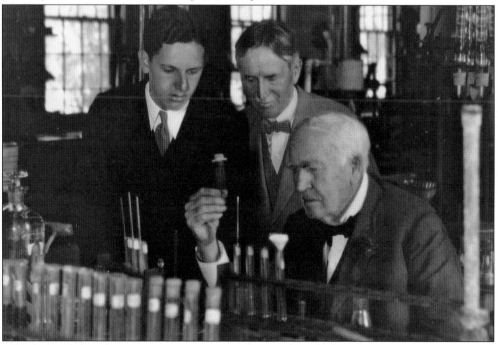

Once ground, plant material was weighed and then taken to the chemical-processing area. Chemical processes such as extraction, distillation, and bromination took place here. The resulting rubber was weighed to determine the percentage of rubber the plant contained. Here, Roger Firestone (left), Harvey Firestone (center), and Thomas Edison examine the results of chemical testing. (Courtesy of Thomas Edison National Historical Park.)

At right, Edison (left) converses with project superintendent Walter Archer in front of a large specimen of goldenrod that is still showcased inside the laboratory office. In total, over 17,000 plant samples were tested by the EBRC, and goldenrod was selected as the favored rubber plant. The plant possessed an ideal set of qualities: it tolerated cold weather, was possible to harvest mechanically, grew quickly, and had a high rubber yield, which could be further increased through cross fertilization. The acres of research beds surrounding the laboratory were soon filled with varieties of goldenrod. Eventually, the EBRC cross-pollinated a variety that grew over 10 feet tall and contained significantly more rubber than the average goldenrod plant. Below, acres of goldenrod growing near the laboratory are pictured here around 1933.

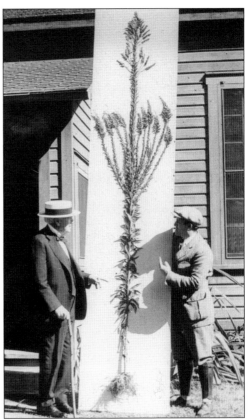

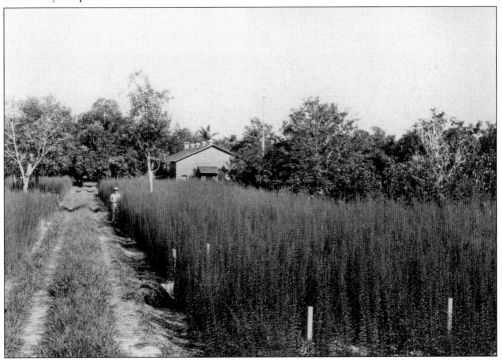

By 1930, Edison had narrowed down his plant selection and fine-tuned the rubber extraction process. It was now time to begin moving toward mass production. This modern image depicts the distillation and extraction apparatus, which was fabricated by laboratory staff. It extracted rubber on a large scale and was designed with the principles of green chemistry in mind; the chemicals used were purified and recycled for reuse.

In October 1931, Firestone and his chemists confirmed that goldenrod rubber was virtually identical in quality to foreign sources of rubber. One of the battery of tests the rubber samples were exposed to is shown here as Firestone employees check the tensile strength—the ability of a substance to stretch without snapping—of the goldenrod rubber.

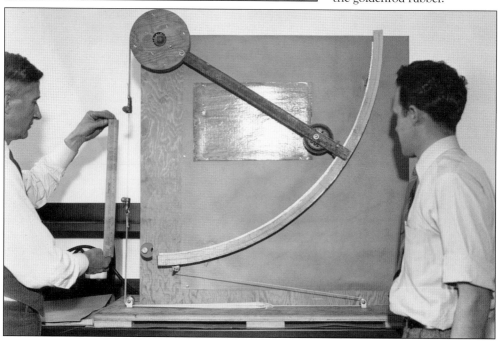

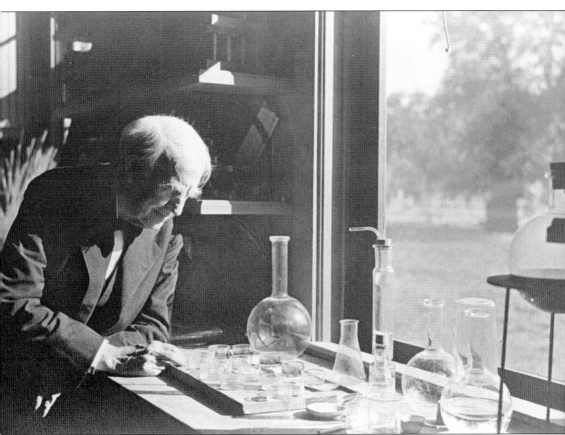

Thomas Edison is seen here examining rubber samples in the Edison Botanic Research laboratory. He remained confident in his success and in his annual birthday interview in 1931, revealed he was two years away from constructing a pilot factory to begin large-scale rubber production. Sadly, eight months later, the most prolific inventor in American history died. The Wizard of Menlo Park received a staggering 1,093 US patents. On October 18, 1931, in memory of the man who perfected the incandescent lighting system, the entire country turned off its lights for one minute, at the request of Pres. Herbert Hoover. After Edison's death, the governor of New York, Franklin Delano Roosevelt, commented, "He was not merely a great inventor—he was a great citizen who was constantly thinking in terms of the good of our country."

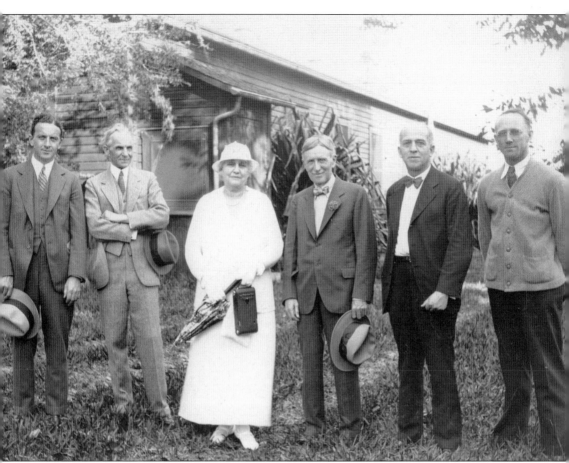

EBRC trustees and staff, from left to right, Russell Firestone, Henry Ford, Mina Edison, Harvey Firestone, Harry Ukkelberg, and John V. Miller stand outside the Fort Myers laboratory in 1934. The EBRC continued Thomas Edison's search for natural rubber until 1936. By that time, synthetic rubber was becoming more practical, and the price of rubber had plunged from a high of $1.23 to just a few pennies per pound. As the Great Depression stretched on, EBRC trustees made the decision to close the laboratory. Even though goldenrod rubber did not become commercially viable, Edison did prove it was possible to extract rubber from smaller plants and bushes, and his work helped pass the Plant Patent Act of 1930, which allowed botanists to patent plants they hybridized. After the loss of her husband, Mina remained active in projects that were important to both of them and began thinking about Thomas Edison's legacy and how best to preserve it.

Seven

FROM PRIVATE
ESTATE TO PUBLIC SITE

[My] faith and belief in the sincerity of the people of Fort Myers prompts me to make this sacred spot a gift to you and posterity as a Sanctuary and Botanical Park in the memory of my honored and revered husband. May you find the possession of it as great a blessing as it has ever been to us.

—Mina Miller Edison, 1947

While Mina Miller Edison may have been overshadowed by her husband's fame throughout his life, she made vast contributions to a wide range of causes. Following Thomas Edison's death, Mina continued her community activities in Florida, New Jersey, and at the Chautauqua Institute, in upstate New York. The institute was a religious summertime adult-education center and movement her father helped found, which spread throughout America. In Fort Myers, Mina established the Round Table, a group overseeing various charitable organizations, and a community activity board, served on beautification committees, and participated in garden clubs.

Mina remarried in 1935, renewing her youthful relationship with Edward Everett Hughes, a former steel-company executive who had vied for Mina's attention as a young man. The couple enjoyed traveling together, including their yearly trips to Fort Myers, until Hughes's death four years later.

In 1946, the Thomas Alva Edison Foundation was formed for the advancement of education and scientific research; Mina served as honorary chairperson. This role may have prompted her to begin thinking of a proper way to memorialize her husband in Fort Myers. She considered a university or library but instead deeded the entire Seminole Lodge property to the City of Fort Myers as a shrine to her late husband. The site developed as a historic house museum and later added a museum building. Just a few months after her generous gift, and 61 years after her honeymoon visit to Fort Myers, Mina Miller Edison passed away. She now rests beside her husband on the grounds of Glenmont, their West Orange, New Jersey, home.

The citizens of Fort Myers, who had honored the revered inventor with annual celebrations and revelry during his life, continued to find new ways to keep his legacy alive after he passed away. Perhaps the greatest single protector of the late inventor's legacy was his wife, Mina Miller Edison.

Mina Miller Edison's early impressions of Fort Myers were not positive. She described Fort Myers during one of her first visits as a "crude, careless place." However, she grew to love the city deeply and became a pillar of the community. After her husband's death, she continued to winter in Fort Myers, further increasing her affection for the city and its residents.

Mina Edison worked tirelessly to champion a number of causes but perhaps was best known for her work to beautify the Fort Myers area. She served on a number of beautification committees, regularly gave tours, and hosted social events on the grounds of Seminole Lodge, as shown here around 1945.

One of Mina's most innovative contributions was the Fort Myers Round Table, a charitable organization that oversaw other charitable organizations. Mina helped found the group and served as its first president. Helping to coordinate efforts of community leaders, the Round Table frequently met at Seminole Lodge. (Courtesy of the Southwest Florida Historical Society.)

One of the best-known events commemorating Thomas Edison's legacy in Fort Myers is the annual Edison Festival of Light. Beginning in 1938, the festival has its roots in the early celebrations of Edison's birthdays in Fort Myers, which involved the entire community. Above, Mina crowns the king of the festival, about 1945. The king and queen were typically area high school students. At left, three-year-old Pamela Jo Garnsden participates in the baby parade during the Festival of Light parade in 1947. Today, the parade has grown to a weeklong event and occurs every February. (Left, courtesy of the Department of Commerce Collection, Florida Memory.)

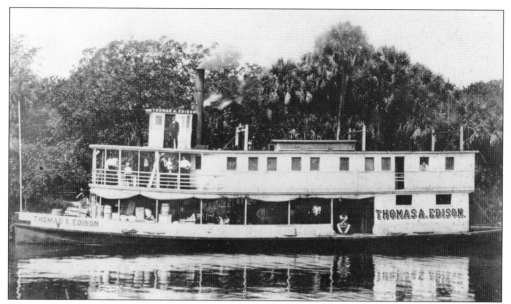

Edison's lasting impact on Fort Myers was evident throughout the community, as dozens of parks, schools, roads, and businesses were named after its most famous winter resident. Here, the Menge brothers' steamboat, *Thomas A. Edison*, navigates the waters of southwest Florida around 1905. Fred and Conrad Menge were Fort Myers boat captains who guided the Edisons on several trips. A close relationship developed between the two families.

Built in the late 1920s, the Edison Park Subdivision and Edison Park School are a testament to Edison's lasting impact on the community. Seen here around 1930, the entrance to Edison Park is across McGregor Boulevard from the residences of Seminole Lodge. The well-known statue *Rachel at the Well* keeps watch over the entrance to the subdivision.

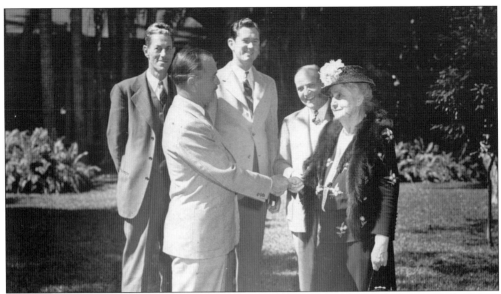

Mina Edison considered many ways to honor Thomas Edison's legacy in Fort Myers. She wrote to a friend in 1932, "Some way he seemed very near to me here different from any other place. We are attached to those in Fort Myers in a different way from others." She eventually decided to deed their beloved Seminole Lodge to the City of Fort Myers in 1947. Mina is seen above handing the key to Seminole Lodge to Fort Myers mayor David Shappard, while family friends and city officials, from left to right, Frank Carson, Graydon Jones, and Sidney Davis look on. Mina passed away later that year, and the Edison estate opened to the public shortly thereafter. The original laboratory garage was converted into a ticket office and museum store. Below, a visitor signs the guestbook in the museum store in 1948. (Below, courtesy of the Southwest Florida Historical Society.)

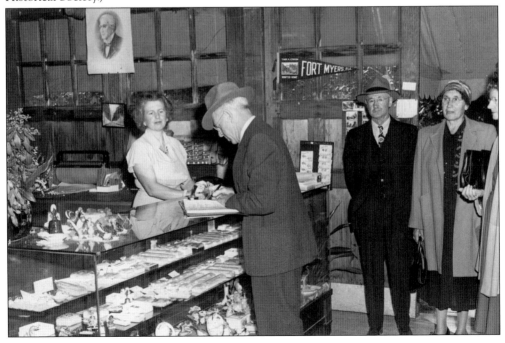

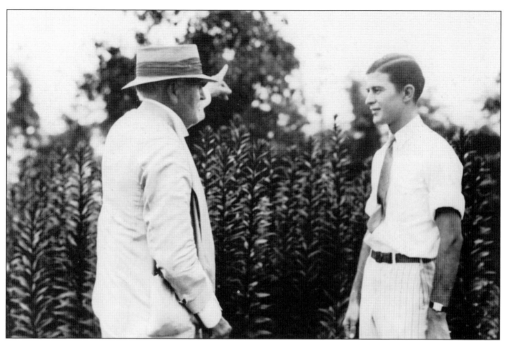

In the late 1920s, brothers Ronald and Robert Halgrim were hired to act as tutors and companions for the Edison grandchildren. Ronald, pictured here with Thomas Edison in front of a stand of goldenrod around 1931, was also a reporter for the local *Fort Myers Press* newspaper. His brother Robert played an important role in further developing Edison's legacy in Fort Myers.

Seen here around 1965, Robert Halgrim (right), who served as manager of the Edison estate, poses with Charles Edison in front of a stand of goldenrod, in some ways mirroring the image above. After Robert's retirement in 1971, his son Robert Halgrim Jr. became manager of the estate until he retired in 1994.

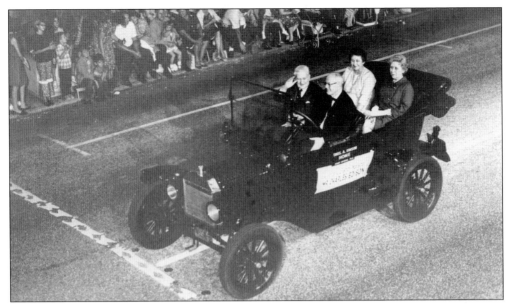

Charles, the middle child of Thomas and Mina Edison, also played a major role in preserving his father's legacy. Here, Charles Edison rides in the Model T given to his father by Henry Ford in 1916. It is driven by Robert Halgrim through the streets of Fort Myers during the Edison Festival of Light parade in 1967.

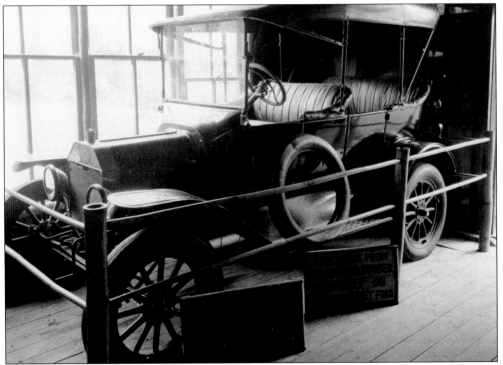

The Model T given to Thomas Edison by Henry Ford was displayed in the converted garage, which served as the museum store, as seen here about 1950. Note the sign inaccurately indicating the tire made from goldenrod rubber, an urban legend that was later discovered to be incorrect.

Early visitors to the Edison Home were able to walk directly through the structures. By the time this photograph was taken in 1972, some barriers had been erected to help preserve the structures and artifacts inside. However, the constant traffic of visitors still took a toll on the historic wooden buildings. (Courtesy of Florida Memory.)

Early interpretations of Seminole Lodge look dated by today's standards—the then-contemporary wallpaper, thick carpeting, and window coverings were likely additions to make the homes look lived-in. Today, the period of interpretation for the homes is 1929, and the items inside reflect the look and function of this period, based on historic resources, including inventories, invoices, and photographs.

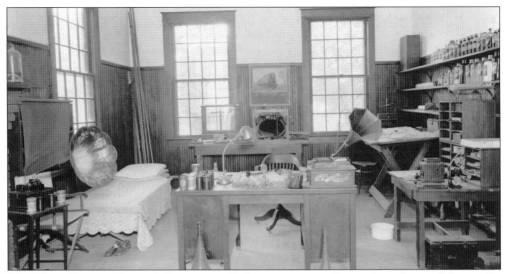

The Edison Botanic Research Corporation Laboratory was inadequately understood during the first several decades that it was open to the public. Note the items out of place in both of these images, taken around 1955; phonographs and lightbulbs, for example, were not relevant to the work performed in this structure. While he was known for taking catnaps, it is no longer believed that Edison used the cot shown in the corner of the above photograph. More likely it was used by traveling plant collectors in the field. Just as in the homes, interpretation is now focused solely on relevant artifacts. In the image below, Robert Halgrim inspects a lightbulb, while John Sloane, grandson of Thomas Edison, looks on. (Below, courtesy of Florida Memory.)

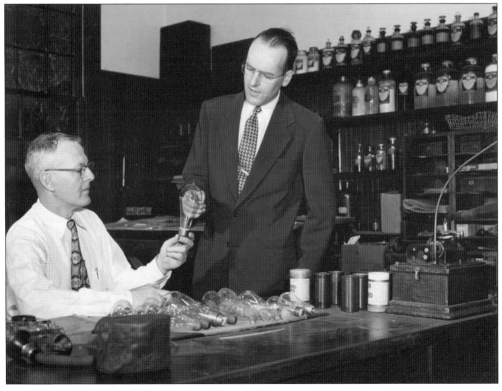

The most iconic landmark associated with the Edison & Ford Winter Estates, the banyan tree, has also changed over the years. The banyan tree is native to Southeast Asia and can grow to several acres in size in ideal growing conditions. When it was planted in the late 1920s, it measured just four feet tall. Note its size in the above photograph, taken around 1960. Below, estate manager Robert Halgrim and a tour group gather under the banyan tree. A fast-growing tropical tree, the banyan must today be trimmed constantly to avoid damaging the nearby historic structures. (Below, courtesy of the Southwest Florida Historical Society.)

Robert Halgrim (third from the left), Charles Edison (third from the right), and others gather around a newly cast statue of Thomas Edison in the Edison museum around 1965. Charles was very active in the development of the fledgling museum—making appearances, donating artifacts, and starting a philanthropic fund that still loans artifacts to the estates today. (Courtesy of Florida Memory.)

Thousands of artifacts were placed on display in the new museum, showcasing Edison's massive variety of inventions. This image from about 1965 showcases a wide variety of phonographs, which Edison called his favorite invention. He referred to the phonograph as his "baby," commenting, "I expect it to grow up to be a big feller and support me in my old age." (Courtesy of the Southwest Florida Historical Society.)

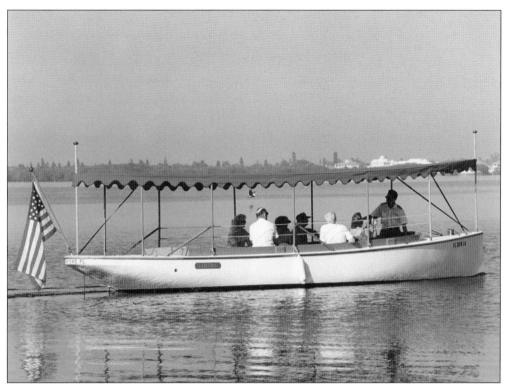

The Caloosahatchee River has always played a crucial role to the City of Fort Myers, the Edison and Ford families, and the estates. Above, visitors ride in a replica of Thomas Edison's boat, the *Reliance*, about 1995. Today, this maritime legacy continues, with river cruises offered from the marina at Edison Ford aboard the M/V *Edison Explorer*, seen below. Visitors are educated about ecology, history, and the importance of the river to the community. In 1912, Mina wrote to her son Charles, "We just came home yesterday from that wonderful trip into Lake Okeechobee . . . You would have thoroughly enjoyed the sawgrass experience and the bird life was most interesting . . . It was a fascinating, weird experience to see that vast expanse of country with those silent moving creatures floating in the air and then setting down in the long grasses lost to sight."

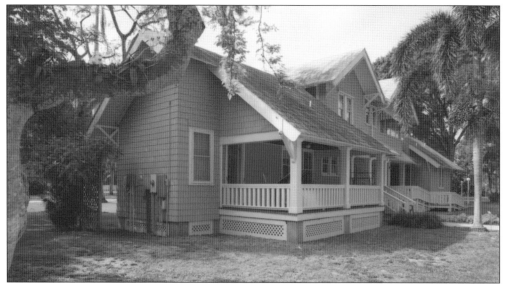

The historic site told the story of Thomas Edison and his family. However, that story was incomplete without including the influence of his neighbor and friend Henry Ford. The Mangoes had been sold to a local family in 1947. In 1988, the City of Fort Myers reached an agreement with the family and purchased the estate. After two years of restoration, the Ford home, seen above, was opened to the public, and the complete story of these two famous friends and their influence on Fort Myers could be told. For the next several decades, the Edison & Ford Winter Estates drew throngs of tourists. The legacies of Edison and Ford in Florida were firmly established, and the future of the historic site seemed bright. But challenges and changes were just around the corner. Below is the interior of the Ford home around 2000—note the extreme wear to the area of the floor the public walked through.

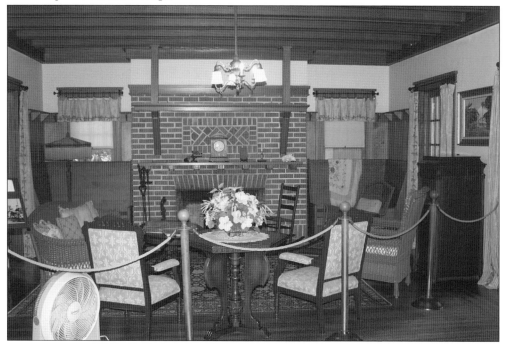

Eight

RESTORATION

AND RENEWAL

It's what is ahead that interests me, not the past.

—Thomas Edison, 1922

By 2001, Seminole Lodge had weathered the southwest Florida climate for 115 years. Millions of visitors had viewed the beloved estate. The wooden buildings had suffered extensive structural damage and needed immediate repair—next door, the Mangoes was also in need of restoration, which included a new roof. The management of the site began to transition from the City of Fort Myers to a private not-for-profit corporation, which would focus solely on preserving the site. Over the next decade, a massive project of restoration and renewal took place. More than $14 million was raised to preserve the site in a way that was in keeping with the values of ingenuity and sustainability so important to Thomas Edison and Henry Ford. In 2006, with restoration well underway, the property formally transitioned to management by the new not-for-profit organization, the Edison & Ford Winter Estates, Inc. In 2009, the site won top awards from the National Trust for Historic Preservation. After work on the buildings was completed, the focus switched to renewing the landscape and formal gardens in keeping with the historical landscape plan. With the help of local and national garden clubs, top awards were also presented to the estates from the National Garden Clubs and National Association of Landscape Architects. Restoration of the Edison Botanic Research Corporation laboratory was completed in 2012. It was designated as a National Chemical Historic Landmark shortly thereafter—the first in the state of Florida. Today, the site remains one of the nation's most visited historic homesites and a national treasure committed to innovation and preservation.

Although the blistering heat and relentless humidity of southwest Florida were factors contributing to the condition of the Edison residences, some of the most extensive damage to Seminole Lodge was caused by invasive insects. Built out of soft wood not native to Florida, the homes readily attracted termites, which severely weakened the structural integrity of the buildings.

Interior damage was present throughout the residences as well. In this image of a second-floor bedroom at Seminole Lodge, note the exposed laths and cracking to the original horsehair plaster walls. Incongruous wallpaper, seen here, was removed. Neutral wallpaper was selected as a replacement because the type of wall covering used by the Edisons in 1929, the period of interpretation for the site, is a topic of ongoing research.

Restoration began with work to stabilize the structures. Years of accumulated damage had placed the structures in a precarious situation—the Guest House was being partially supported by the chimney, due to deteriorating support beams. Stabilization of the brick piers underneath the structures and strengthening of support beams was a critical first step.

Architects utilized primary source materials and field investigation to better understand the historic structures; sketches, invoices, inventories, and correspondence were all used to determine basic details about the original construction of the homes. Because of the intensive restoration process, estates staff today have a better understanding of the evolving architecture of the homes.

Above, siding and interior laths are exposed during the restoration of Seminole Lodge. Each piece of wood that was removed for restoration was numbered, treated to prevent further termite damage, and if possible, returned to its original location. Any lumber too damaged to be placed back into the structure was replaced with wood of a similar type, as stipulated by the Secretary of Interior's Standards for the Treatment of Historic Properties.

Here, contractor Robert Weaver is seen removing paint from a piece of siding. Skilled craftsmen were involved in every step of the award-winning restoration process, including performing architectural research, carefully removing paint, reglazing windows, performing carpentry on original wood pieces, and a variety of other tasks.

Among the most important interior-design elements of the homes, the electroliers of Seminole Lodge required extensive restoration. Above, a disassembled electrolier is seen in the early stages of repair. These fixtures were among the earliest ceiling-hung electric lights. Edison developed the fixtures, which were similar to the gas-powered fixtures of the day, known as gasoliers. Each electrolier was uniquely designed and fabricated by Bergmann & Co. Today, the fully restored electroliers, as seen at right, are all original, except for the lightbulbs and electrical wiring.

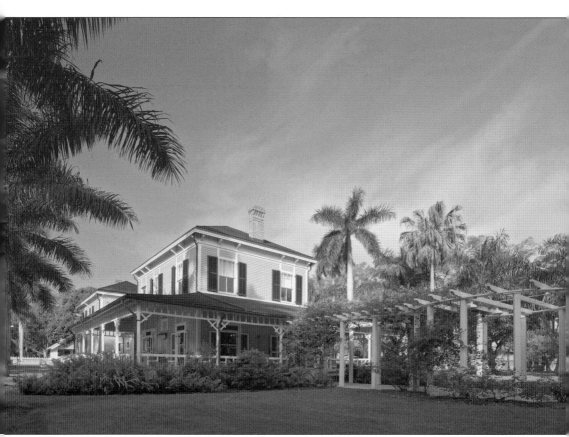

Seen here is the fully restored Seminole Lodge Guest House. During the process of restoration, sustainable modern enhancements were utilized whenever possible to prevent further damage from termites and storms. Replacing wood lattice located near the foundation of the homes with lattice made from recycled plastic helped to avoid reintroducing termites to the homes. Replica shutters were created based on the original design but with the addition of a water-shedding material on the reverse side that is reinforced to stand up to hurricane-force winds. Copper gutters, replicating the originals, were installed, allowing water to be directed away from the structures and into the surrounding area, preserving the buildings while sustaining the lawn. Finally, a state-of-the-art fire-suppression system was added to protect all of the historic structures. A traditional water sprinkler system can damage wooden structures and delicate artifacts; to avoid this, a Borrell mist-based system was installed.

Above, the long-neglected Edison caretaker's house also required extensive restoration. Removal of modern shag carpeting and a drop ceiling revealed original yellow pine flooring and simply constructed walls made of salvaged local lumber. When the building was originally constructed, only rough-hewn wood was available, as there were no lumber mills in the area. The restored caretaker's house, seen below, reflects the building as it stood in 1929, the period of interpretation of the site. Unlike in the other historic structures, air-conditioning and modern lighting were added to this building so that it could be used for educational programming, summer camp classes, and as a space to display exhibits.

Seen here, the Edison fountain has been drained in preparation for restoration. The fountain was an important landscape feature for the Edisons. During their time, it was changed from its original finish of smooth cement to a combination of coquina, coral, and limestone, giving it a more rustic appearance. A naturally occurring rocky formation found in Florida, coquina was a popular building material in the early 20th century.

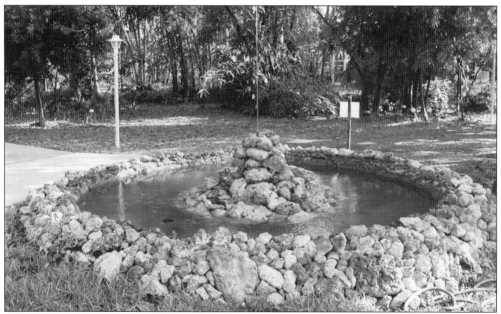

Here, the fountain is fully restored and functional once more. During restoration, the rocky finish was carefully maintained. Later, tabby pavers were added throughout the site, replacing the concrete pathway seen in the background. These porous pavers are composed of a material similar to the coquina fountain, improving drainage and preventing standing water on the walkways of the site.

Henry Ford's winter home also required restoration, even though the local lumber used in constructing the house stood up to the Florida climate better than the soft nonnative wood that was used in the Edison home. After the City of Fort Myers purchased the home in 1988, work focused on restoring the original design of the house and reversing changes that had been made to modernize the structure. Seen above, workers replace the rusted tin roof added by Henry Ford with a composite material called Galvalum, selected due to its longevity, weather resistance, and close similarity to the original material. The house received electrical updates, and like at all historic structures open to the general public, ramps were added to improve access. Seen below is the structure after extensive restoration was completed.

After restoration of the Edison and Ford residential structures was complete, work began on the Edison Botanic Research Corporation Laboratory. Considered to be the most historically significant structure on the site, the laboratory underwent extensive restoration. Here, workers clean, scrape, and repaint the original windows, which had been damaged by water intrusion.

The laboratory's badly rusted roof, seen here, needed to be replaced, and the foundation required stabilization. The nearby banyan tree presented a challenge to preserving the structure—overhanging branches dropped debris on the roof, and root systems threatened the foundation if not continually controlled. While the roof was being replaced, a temporary storage space was erected inside the museum to store the laboratory's fragile artifacts.

Today, the restored laboratory is presented as it looked in 1929, but it also includes modern features designed to preserve the structure: hurricane straps, which secure the roof and foundation in high winds, a security system, modern electrical wiring, and a new fire-suppression system. Through the use of primary source materials such as inventories, photographs, and research notebooks, a historically accurate interpretation was achieved. A variety of consultants also contributed, including chemical, machine shop, and glassblowing experts. In 2012, restoration of the laboratory was completed, and soon after, it was designated as a National Chemical Historic Landmark by the American Chemical Society. Here, the fully restored chemical-processing area of the laboratory is shown. The tables in this area were arranged in a systematic fashion. Similar to an assembly line, employees would use each table for a different purpose, from preparing plant samples for testing and performing chemical tests to analyzing results.

While the historic structures took priority, the landscape also needed to be returned to its original condition. To that end, a historic landscape plan was developed to guide the restoration. In particular, the Moonlight Garden, a favorite place on the property for Mina Edison, needed attention. In the photograph above, the fountain is being refinished to prevent leaks. Next, the original blue and white foliage was replanted. In 2008, the estates received the top award from the National Garden Clubs. Today, the Moonlight Garden is once again a place for restful reflection, as seen below.

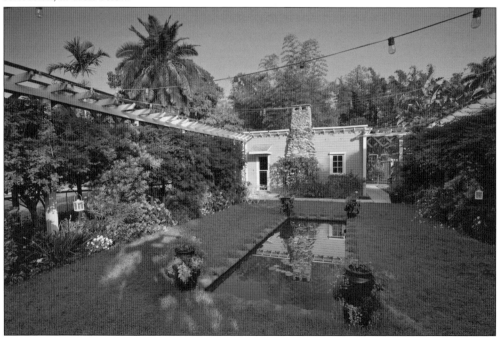

Mina Edison and Clara Ford both had a love for formal gardens—especially roses. Clara had a massive rose garden at her year-round estate of Fair Lane, containing over 11,000 varieties of roses from all across the globe. At her year-round estate of Glenmont, Mina had a greenhouse bursting with orchids, roses, and other flowers. Today, their love of flowers is celebrated at the estates with a rose garden honoring each woman. Above is a rose garden created near the Main House of Seminole Lodge to honor Mina Edison, and at right, a rose garden adjacent to the Mangoes honors Clara Ford's love of roses. Both gardens feature heirloom varieties of roses, as well as hybrid varieties suited to the Florida climate.

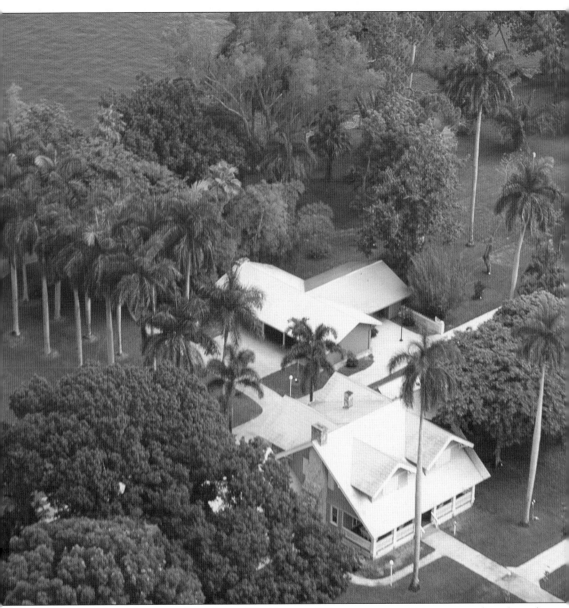

Thomas Edison first visited southwest Florida over 130 years ago, and his presence has shaped the history of the region since then. In the past decade, award-winning restoration has ensured a bright future for the estates. Visited by more than 225,000 guests a year, the site features a thriving membership program, with reciprocal affiliations at other sites throughout the country, and new and innovative exhibits and programs in science, history, and the arts. The impact of

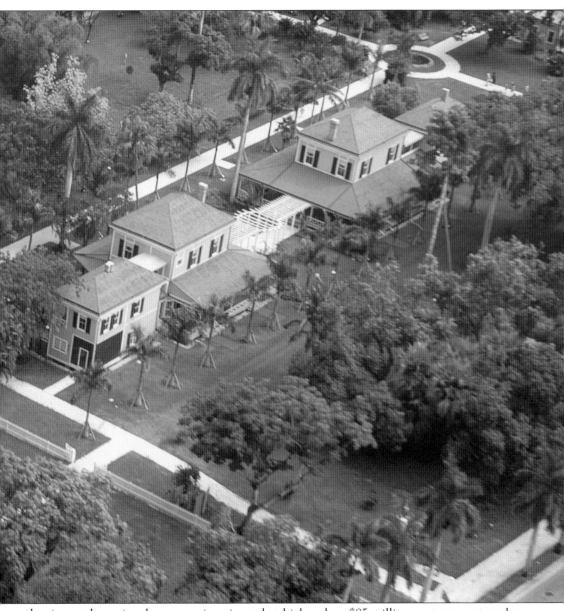

the site on the regional economy is estimated at higher than $85 million—a testament to the lasting impression left by Edison and Ford on the area. The impact of these two men on Florida and, indeed, the entire world, is clearly visible. Today, the Edison & Ford Winter Estates look to the future and a renewed commitment to preserving the legacies of these American icons for future generations.

BIBLIOGRAPHY

Albion, Michele W. *The Florida Life of Thomas Edison*. Gainesville: University of Florida, 2008.

Baldwin, Neil. *Edison: Inventing the Century*. Chicago: Chicago Press, 1995.

Brinkley, Douglas G. *Wheels for the World: Henry Ford, His Company, and a Century of Progress*. New York: Penguin, 2004.

Bryan, Ford R. *Clara: Mrs. Henry Ford*. Detroit: Wayne State University Press, 2001.

Freeberg, Ernest. *The Age of Edison: Electric Light and the Invention of Modern America*. New York: Penguin, 2014.

Israel, Paul. *Edison: A Life of Invention*. New York: John Wiley & Sons, 1998.

Smoot, Tom. *The Edisons of Fort Myers*. Sarasota, FL: Pineapple Press, 2004.

Venable, John D. *Mina Miller Edison: Daughter, Wife And Mother of Inventors*. Newark, NJ: Charles Edison Fund, 1981.

Watts, Steven. *The People's Tycoon: Henry Ford and the American Century*. New York: Vintage Books, 2005.

ABOUT THE ORGANIZATION

Visitors to the Edison & Ford Winter Estates in Fort Myers will enjoy more than 20 acres of historical buildings and gardens, including the 1928 Botanical Laboratory and the Edison Ford Inventions Museum. They will also enjoy a variety of programs, tours, and activities, plus time to explore this unique tropical site, which has been restored to reflect the period of 1929.

In addition to tours and visitor activities, Edison Ford offers school and education tours for all ages, an extensive summer camp program, homeschool classes, emerging inventors, and activities for toddlers, as well as travel and off-site tour opportunities. Other specialty programs include Holiday Nights (rated one of the nation's top 10 holiday events), Black Maria Film Festival, antique car shows, garden talks, and a wide variety of other events throughout the year.

The Edison & Ford Winter Estates is a National Register Historic Site and received the Award of Excellence for restoration from both the National Trust for Historic Preservation and the National Garden Clubs, Inc. The site is also a Florida Historic Landmark and has been designated as a National Chemical Landmark by the American Chemical Society.

Open to the public since 1947, the Edison & Ford Winter Estates is one of the most visited historic homesites in America. It is open daily, 9:00 a.m. to 5:30 p.m., and until 9:00 p.m. throughout the month of December for Holiday Nights, and is closed Thanksgiving and Christmas Days. For more information, or to get involved, call (239) 334-7419, or visit the Edison Ford website at www.edisonfordwinterestates.org.

127

DISCOVER THOUSANDS OF LOCAL HISTORY BOOKS
FEATURING MILLIONS OF VINTAGE IMAGES

Arcadia Publishing, the leading local history publisher in the United States, is committed to making history accessible and meaningful through publishing books that celebrate and preserve the heritage of America's people and places.

Find more books like this at
www.arcadiapublishing.com

Search for your hometown history, your old stomping grounds, and even your favorite sports team.

Consistent with our mission to preserve history on a local level, this book was printed in South Carolina on American-made paper and manufactured entirely in the United States. Products carrying the accredited Forest Stewardship Council (FSC) label are printed on 100 percent FSC-certified paper.

MADE IN THE USA